FROM THE LIBRARY OF

GARY METZ

A 1972 GRADUATE OF VISUAL STUDIES WORKSHOP. GARY METZ WAS
AN ACCOMPLISHED PHOTOGRAPHER AND NOTABLE SCHOLAR.

OCTOBER 14, 1941 – SEPTEMBER 28, 2010

SZE TSUNG LEONG HORIZONS

SZE TSUNG LEONG HORIZONS

WITH ESSAYS BY CHARLOTTE COTTON, DUNCAN FORBES, PICO IYER, AND SZE TSUNG LEONG,

AND A CONVERSATION BETWEEN THE ARTIST AND JOSHUA CHUANG

HATJE
CANTZ

CONTENTS

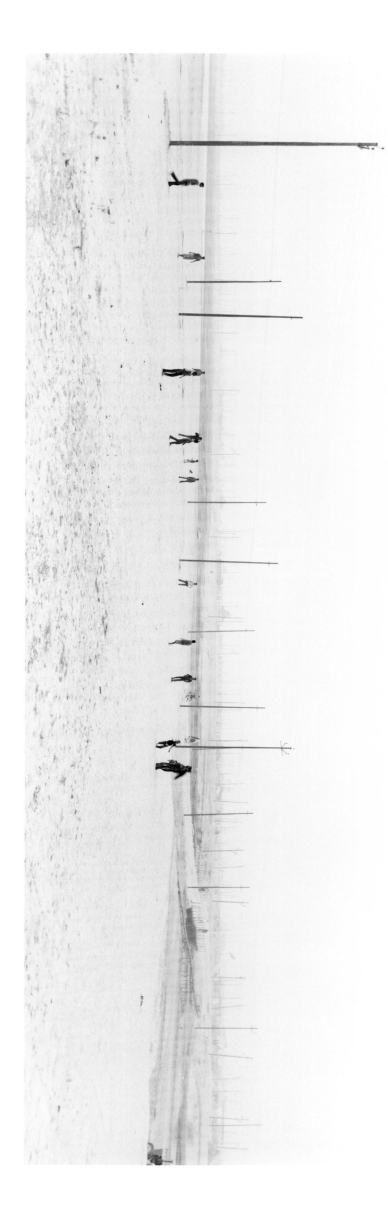

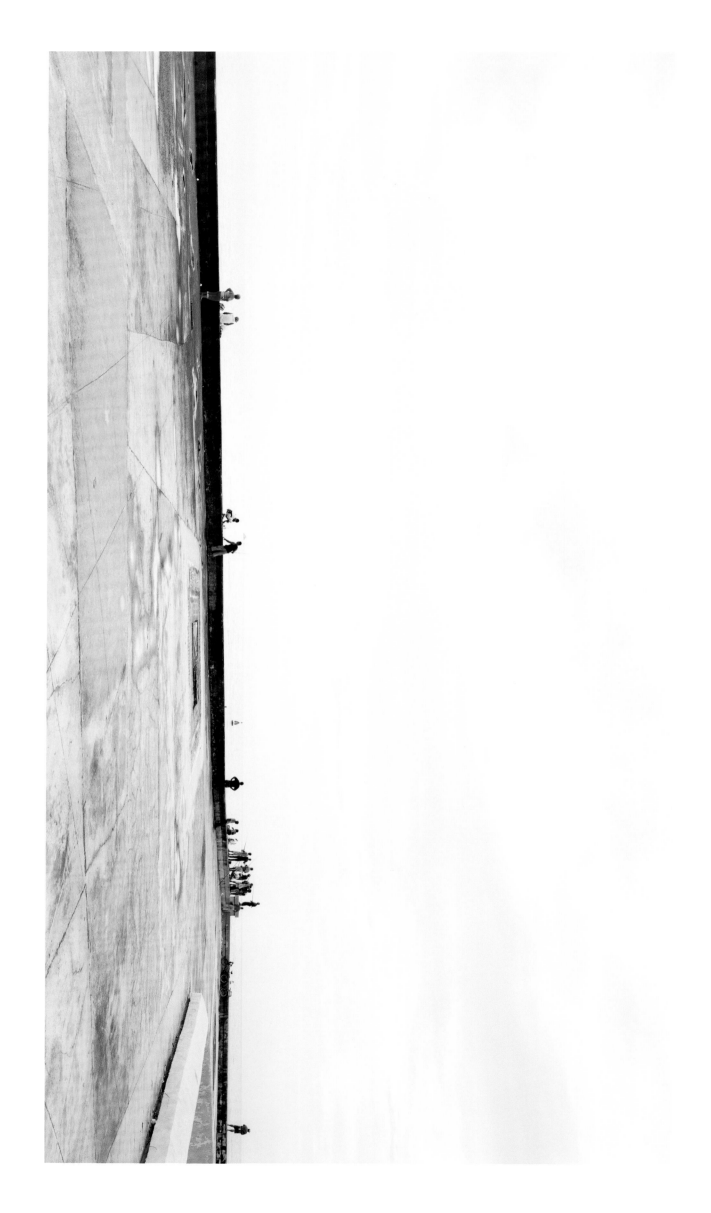

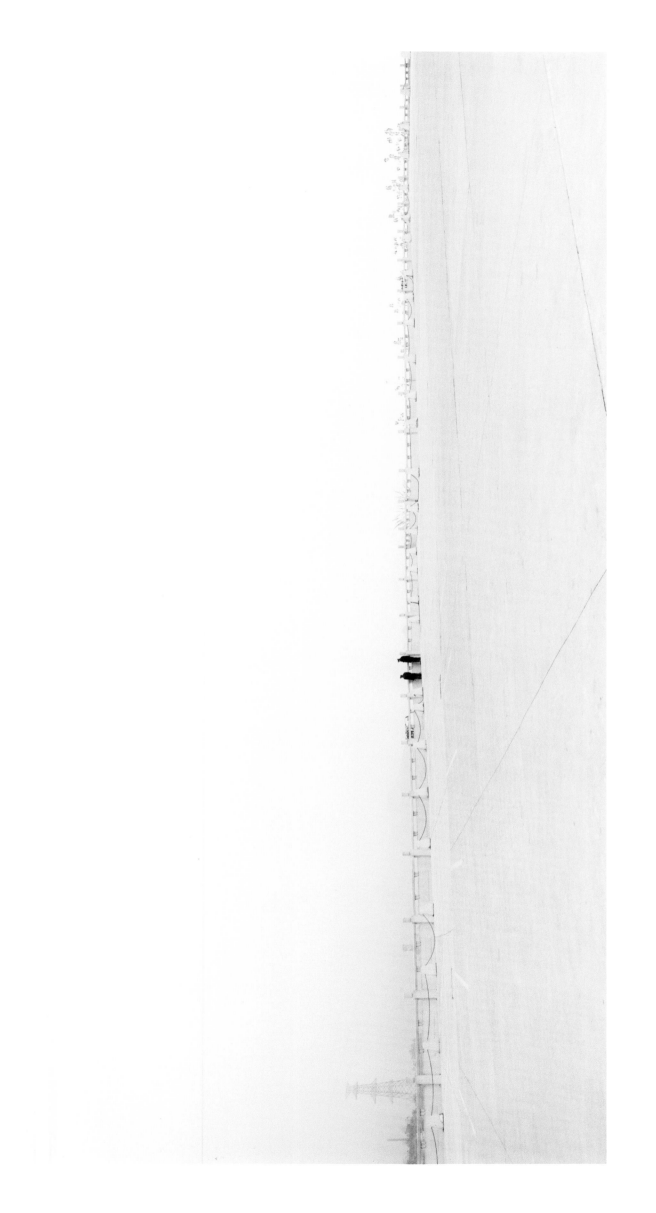

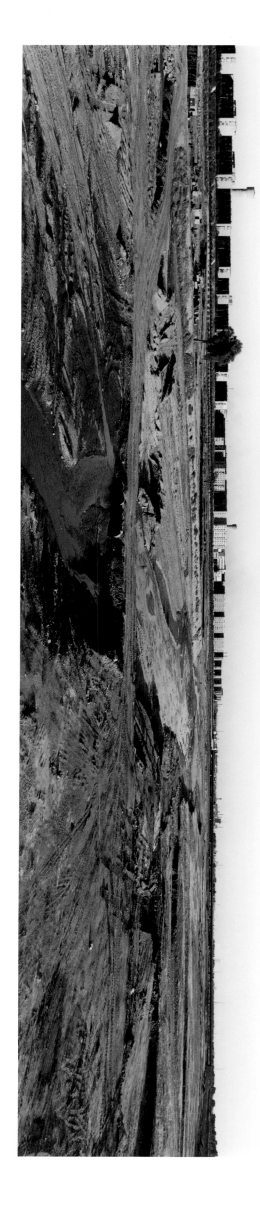

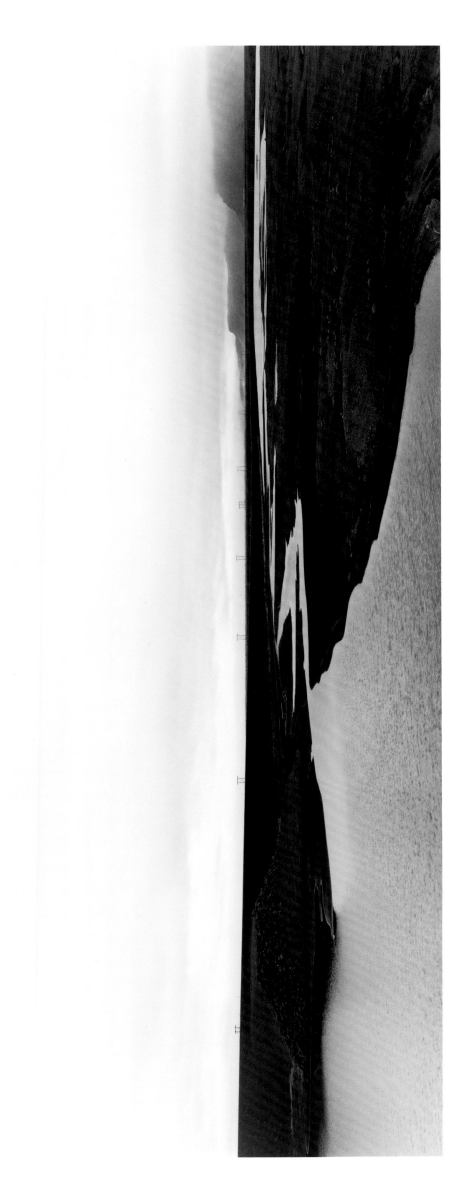

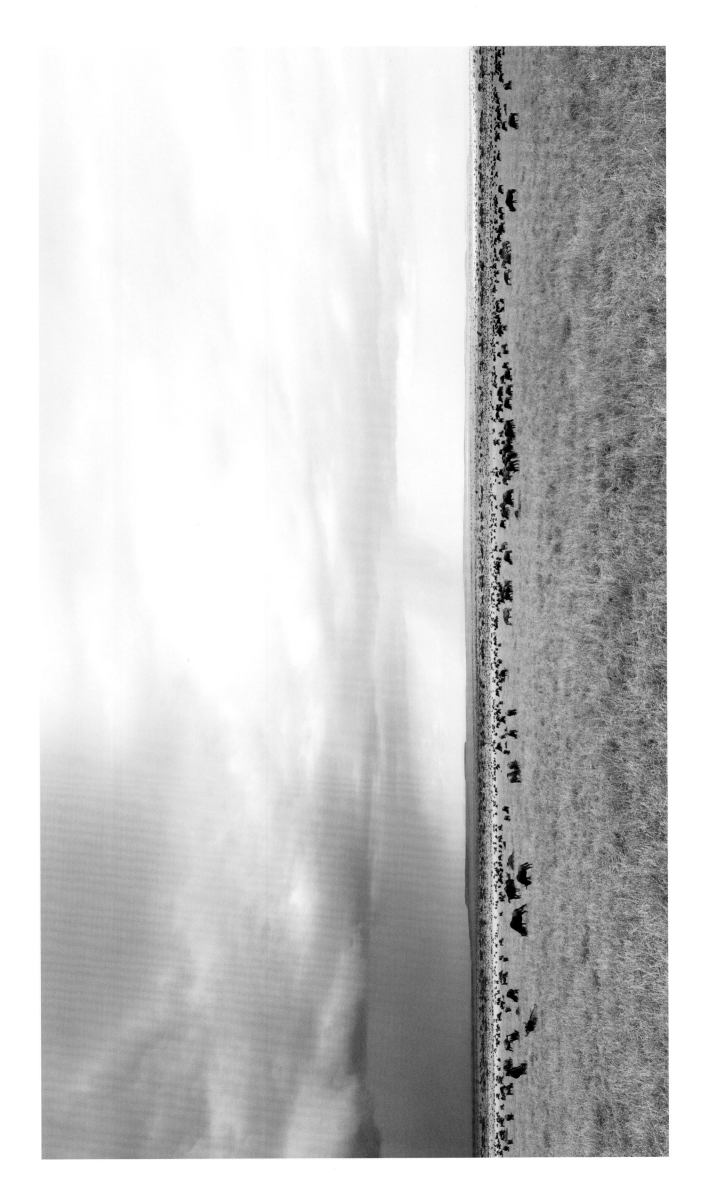

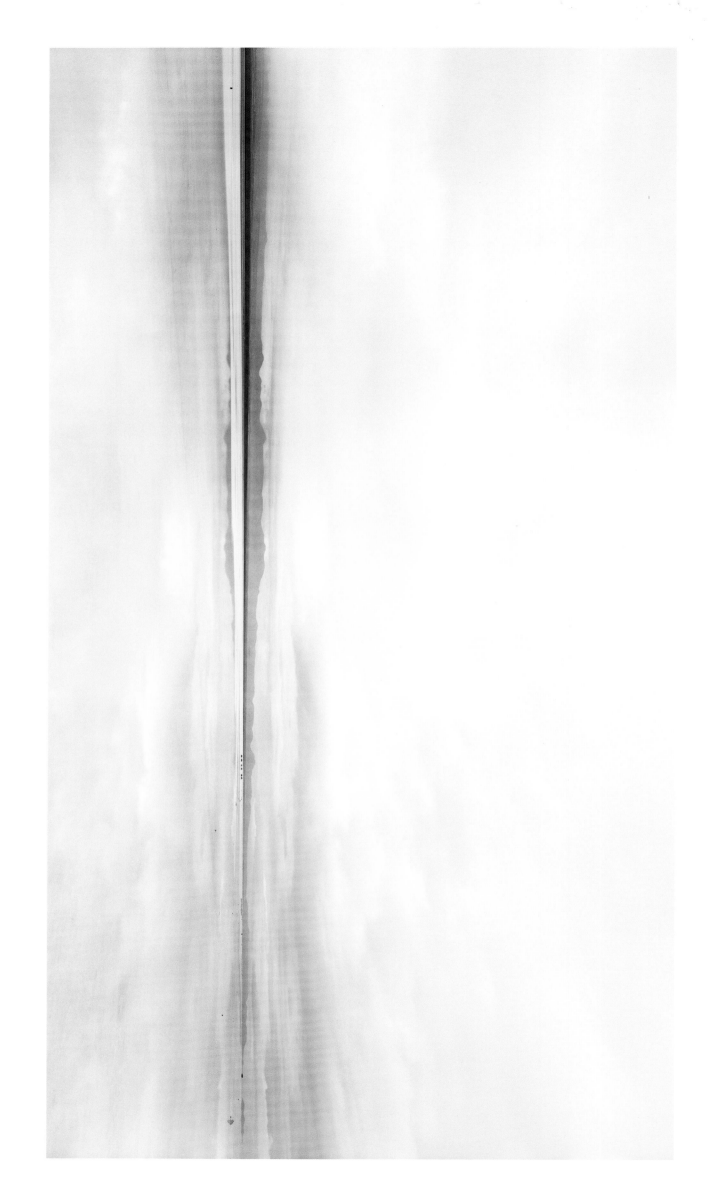

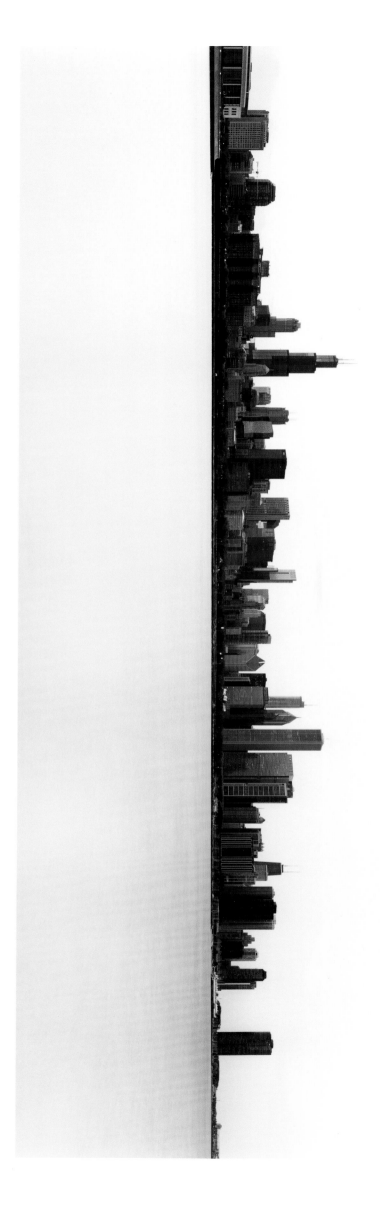

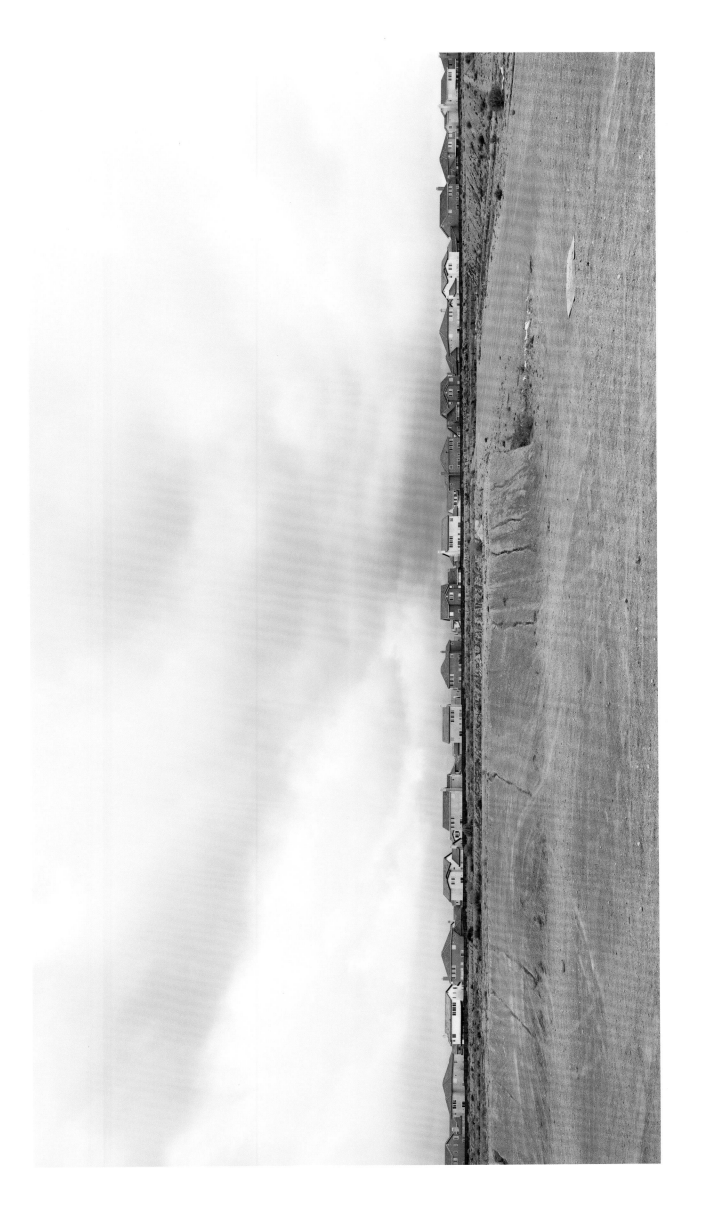

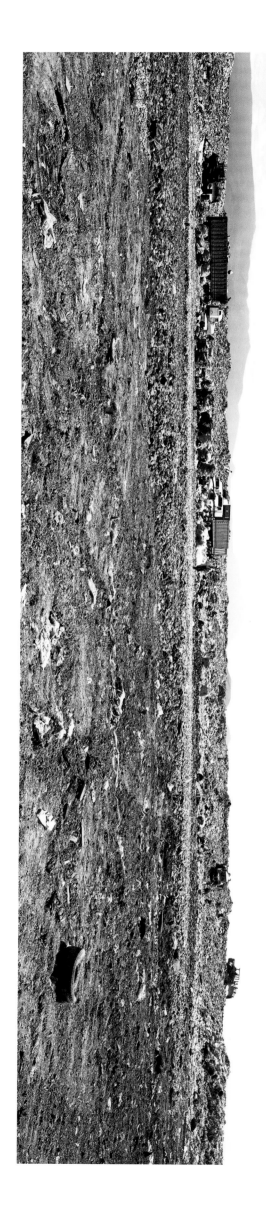

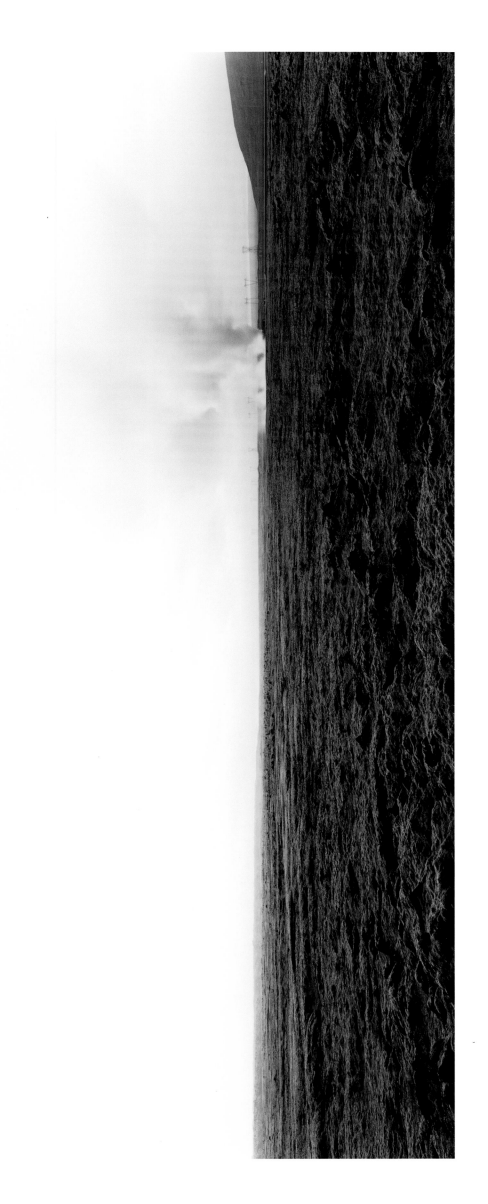

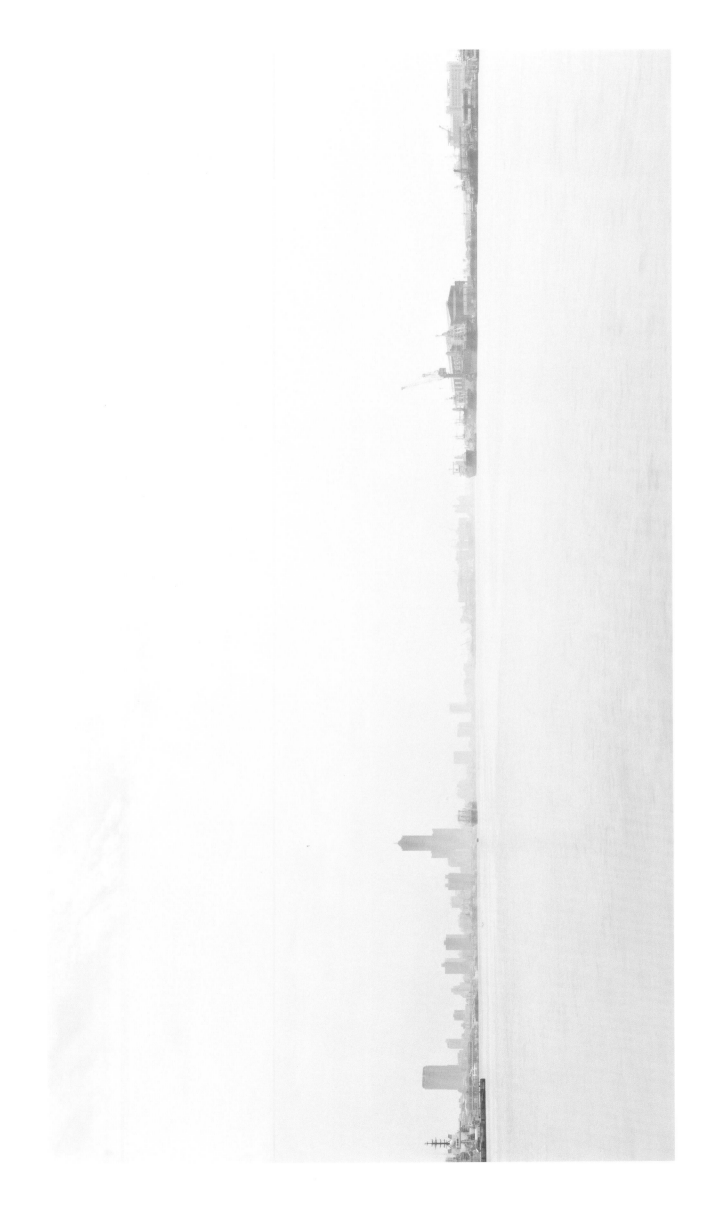

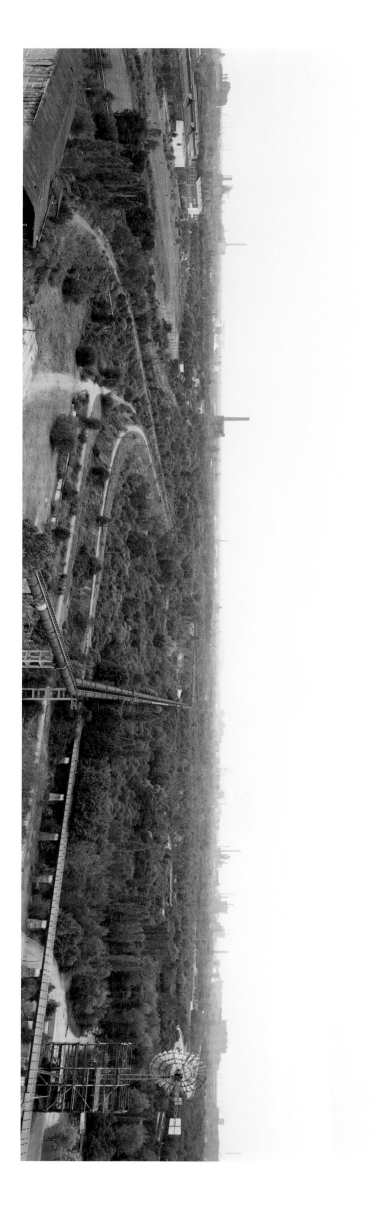

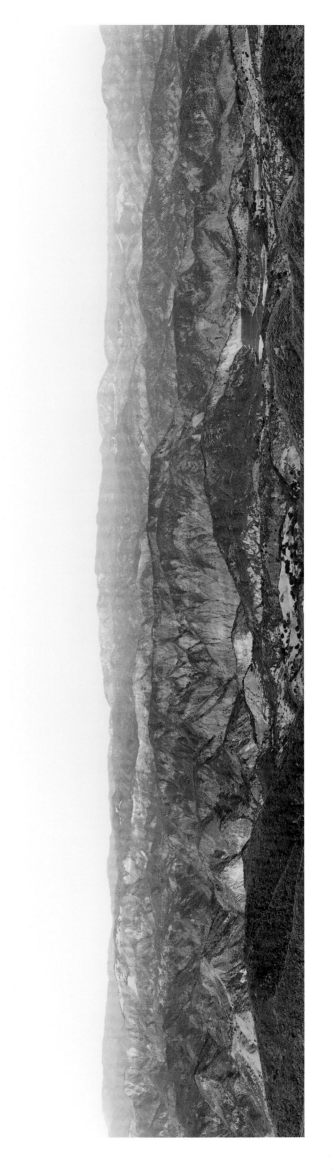

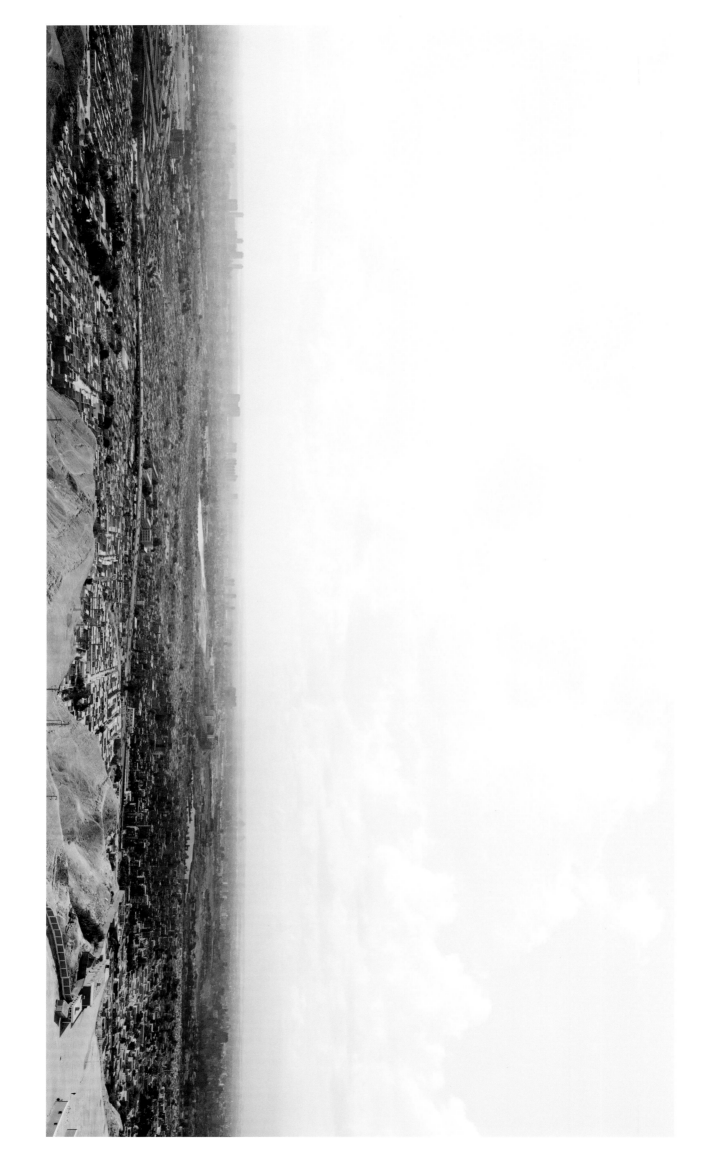

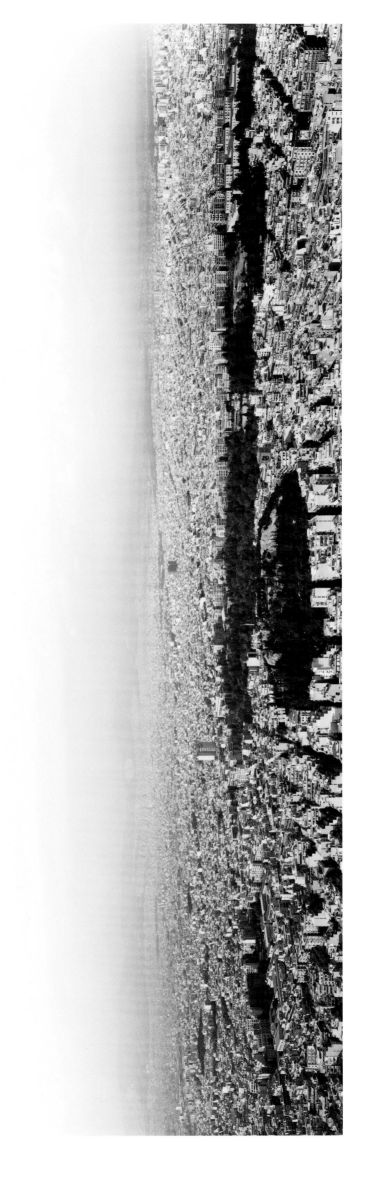

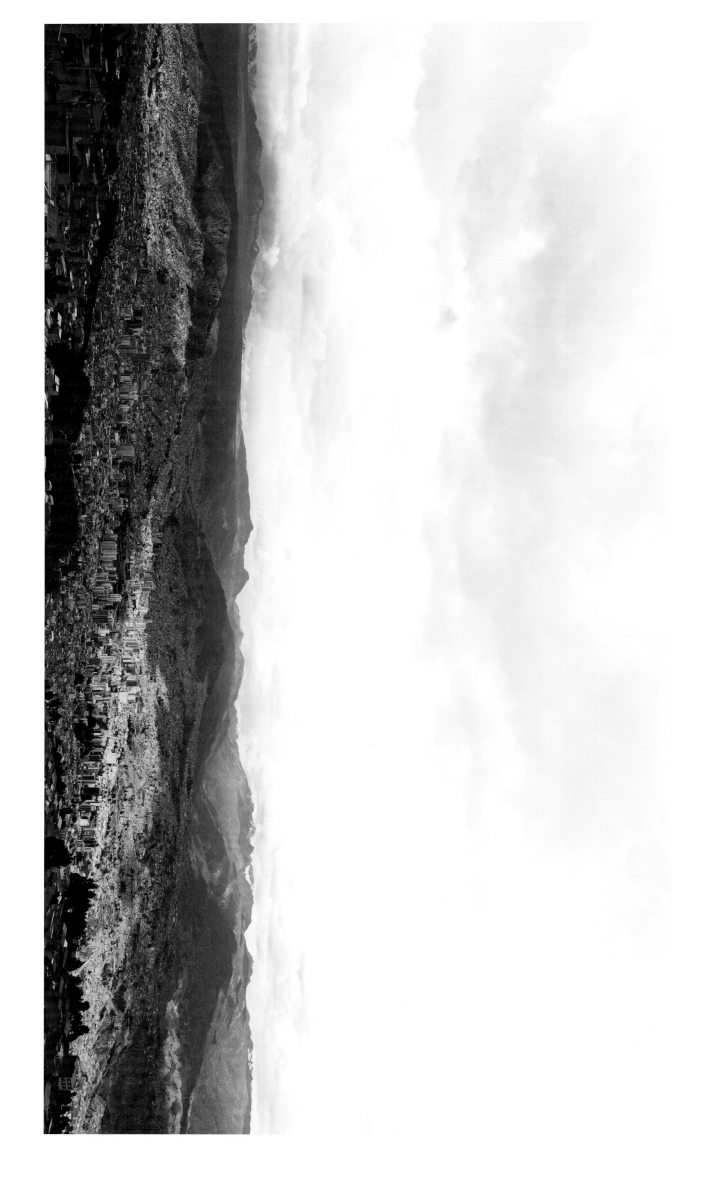

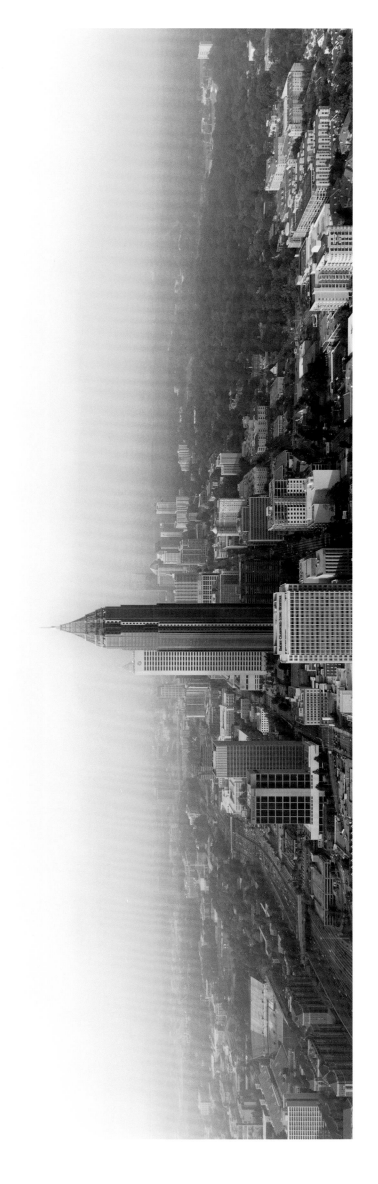

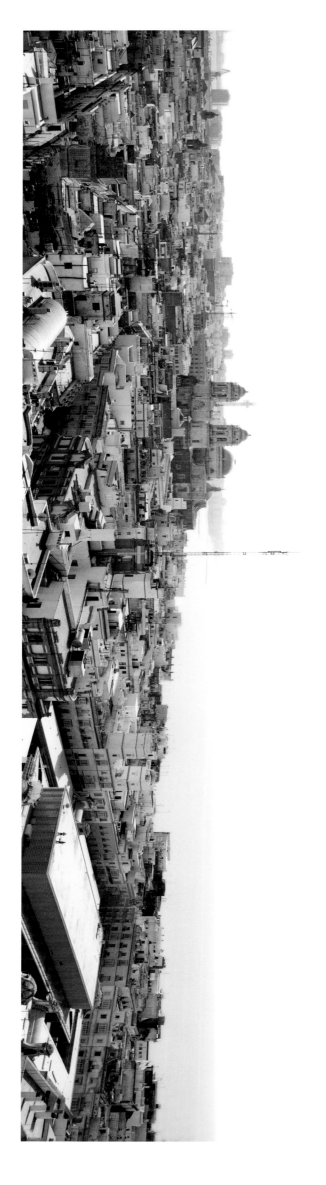

38

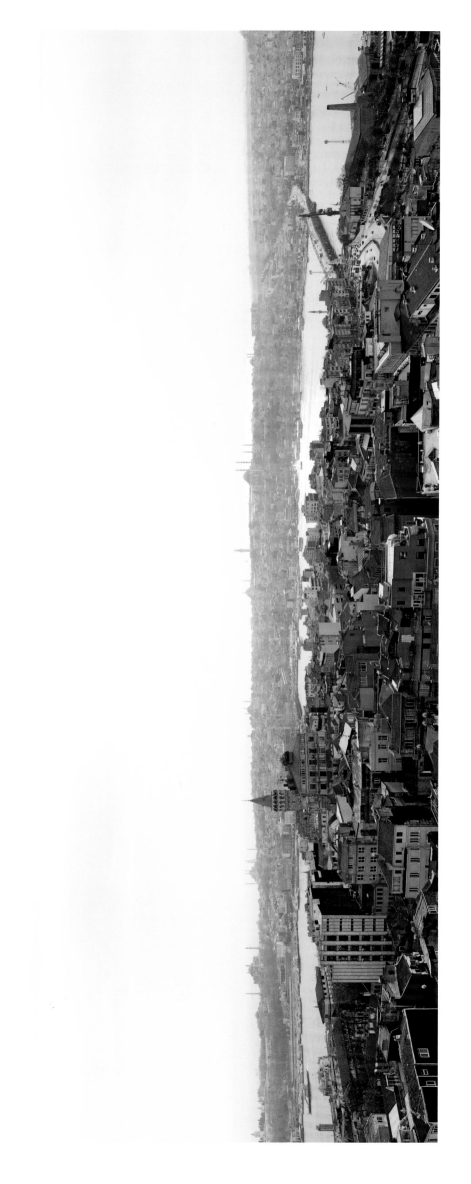

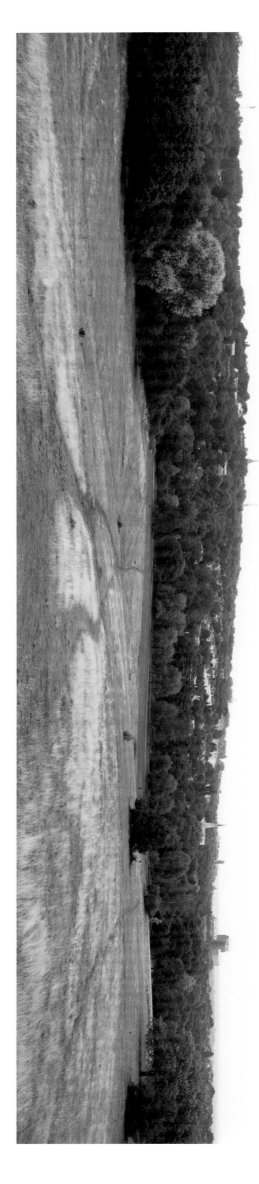

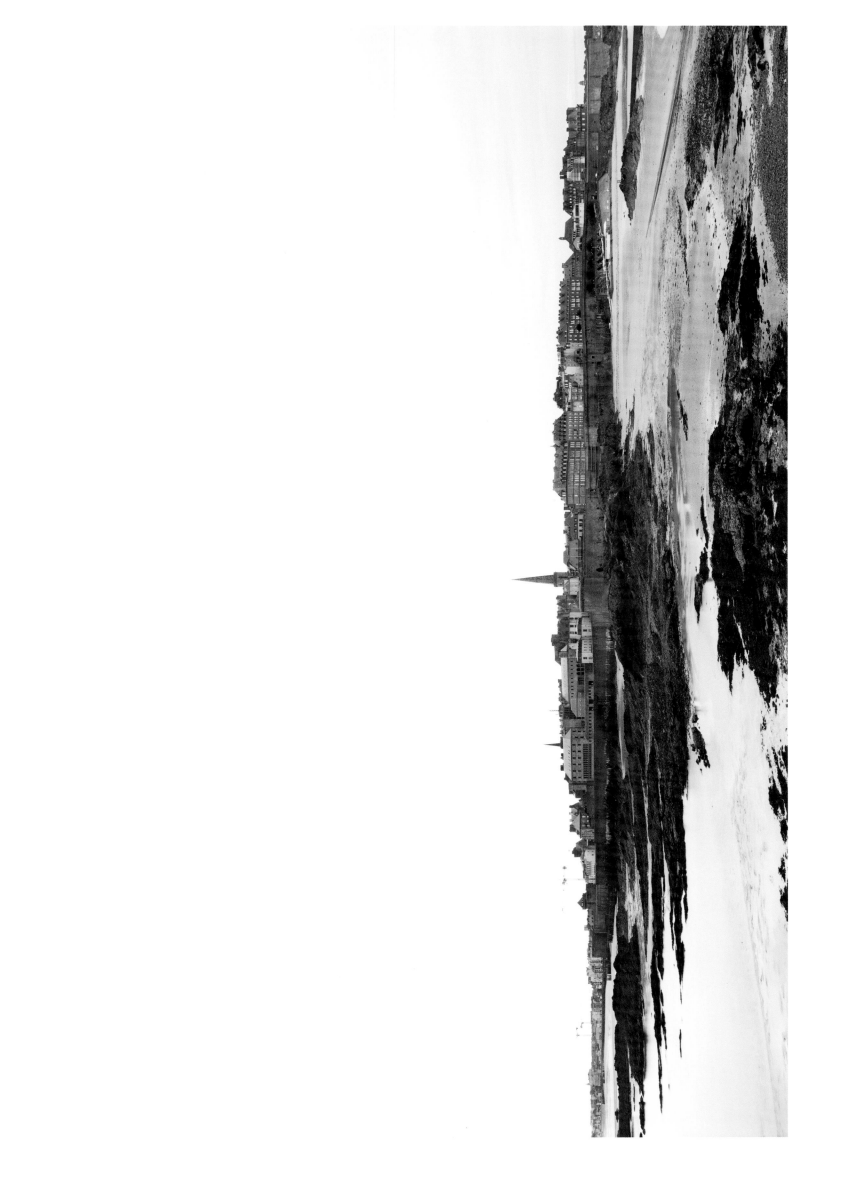

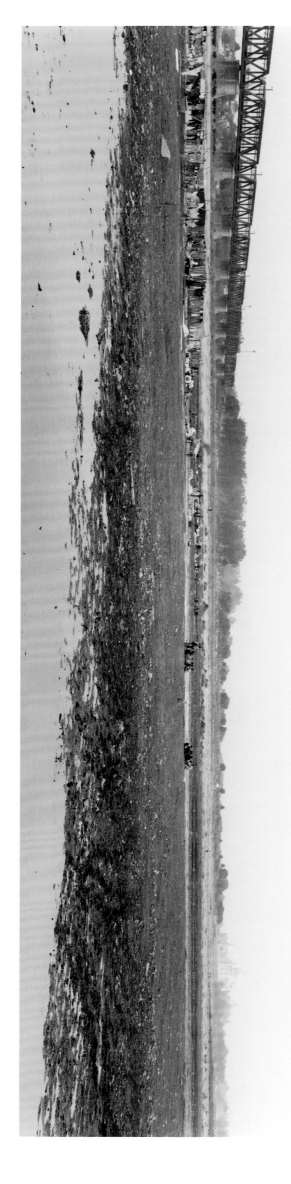

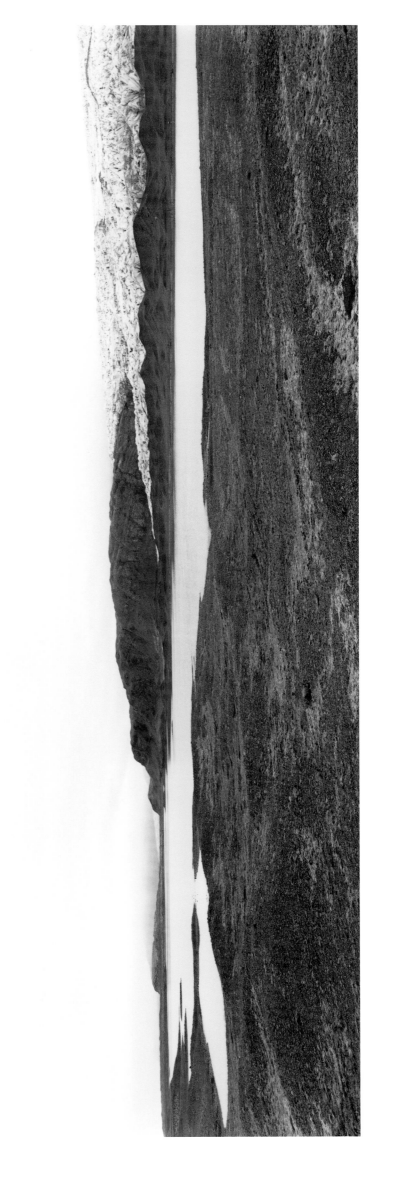

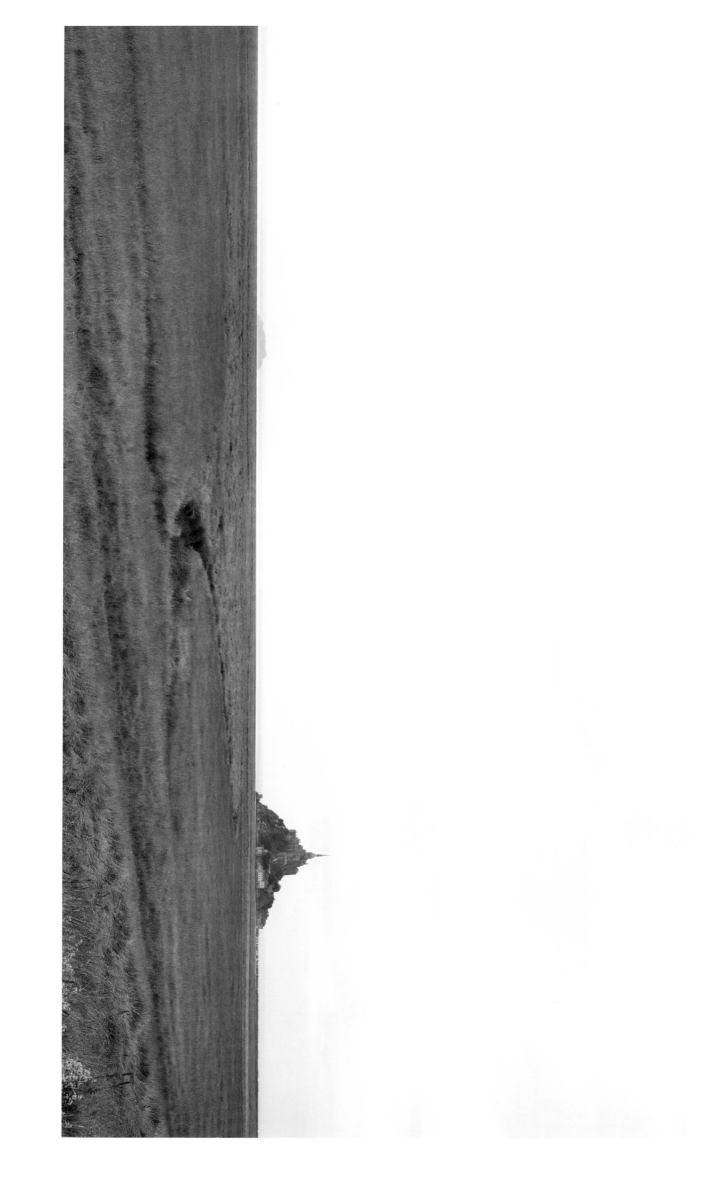

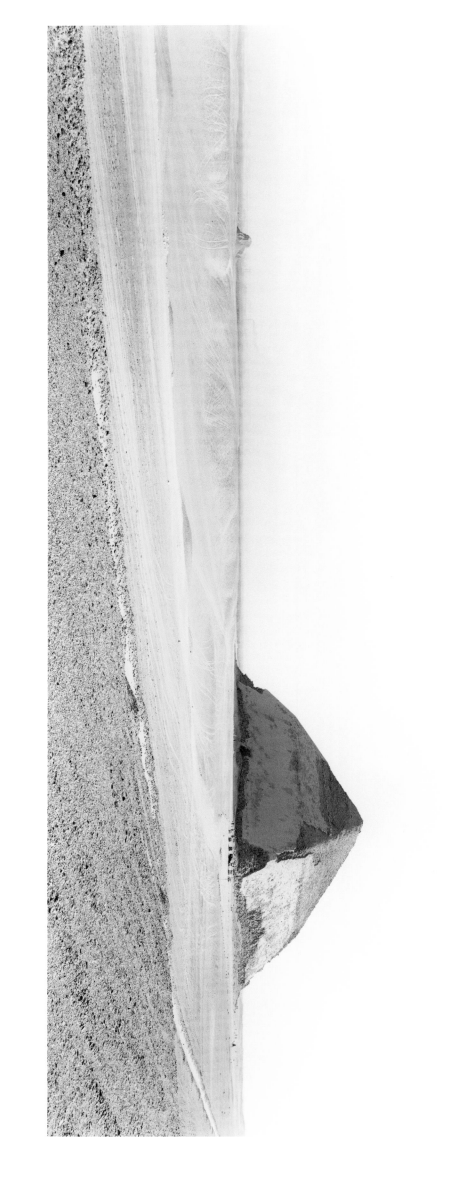

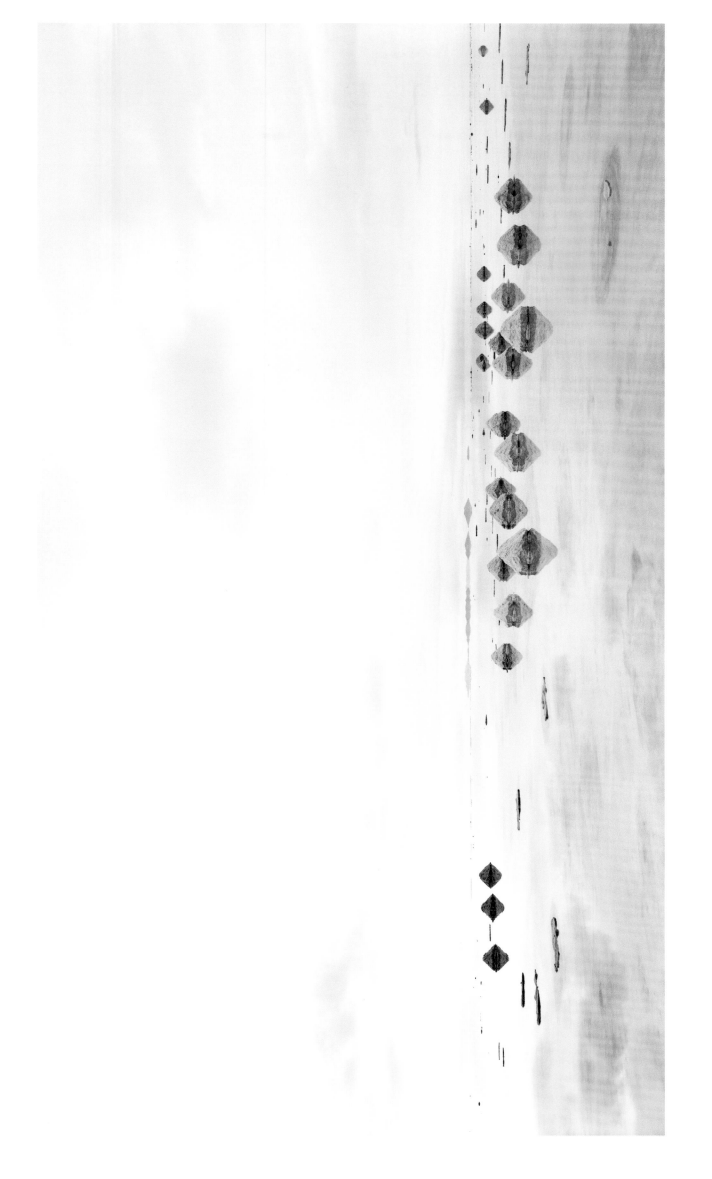

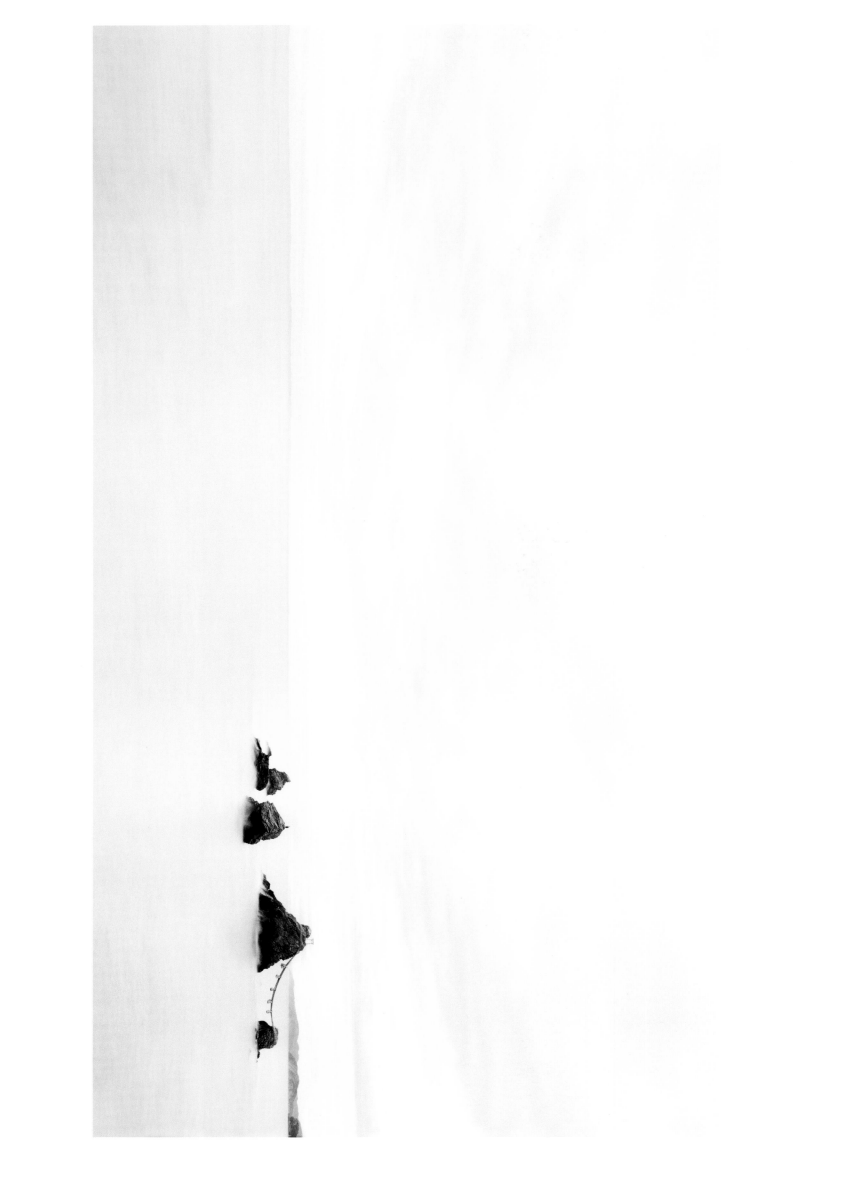

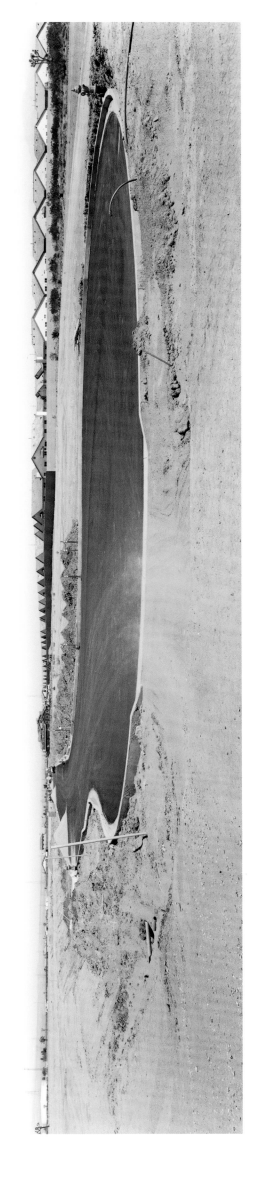

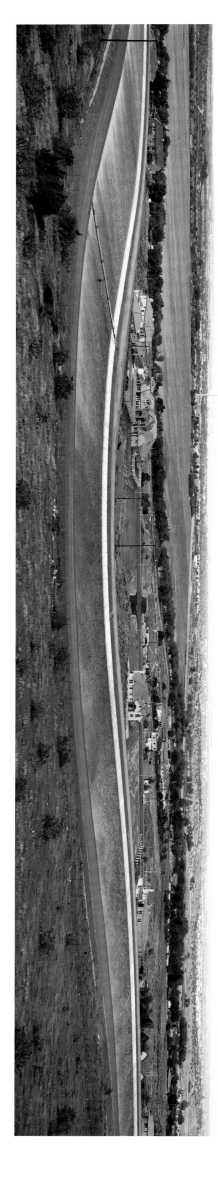

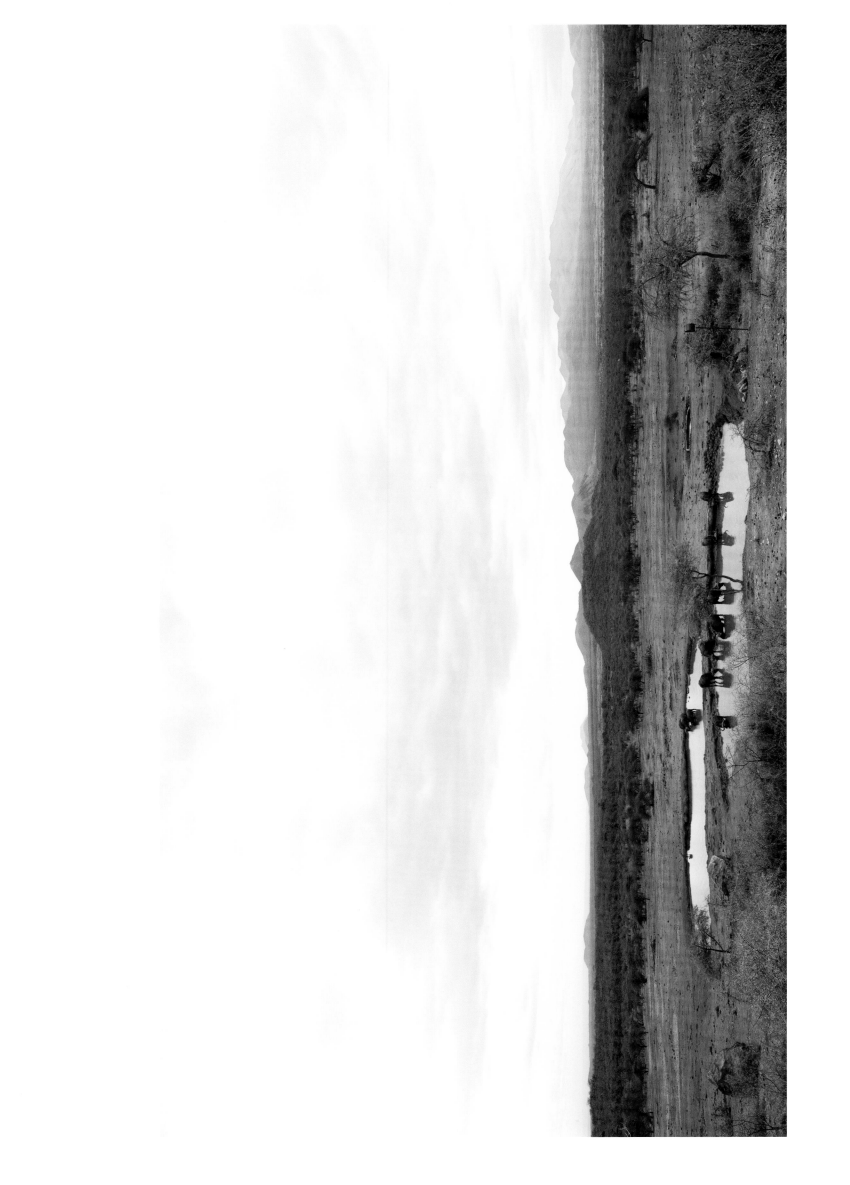

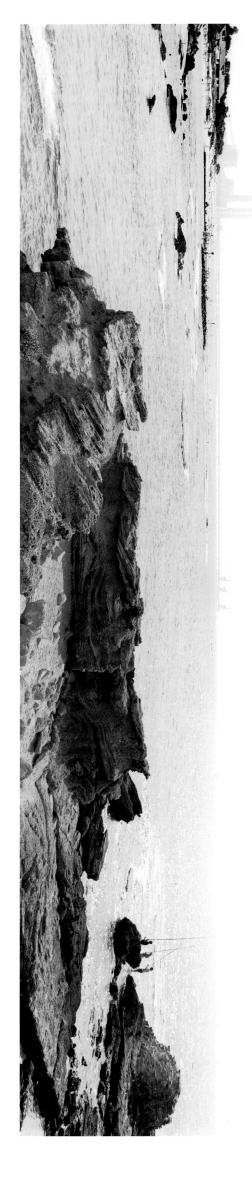

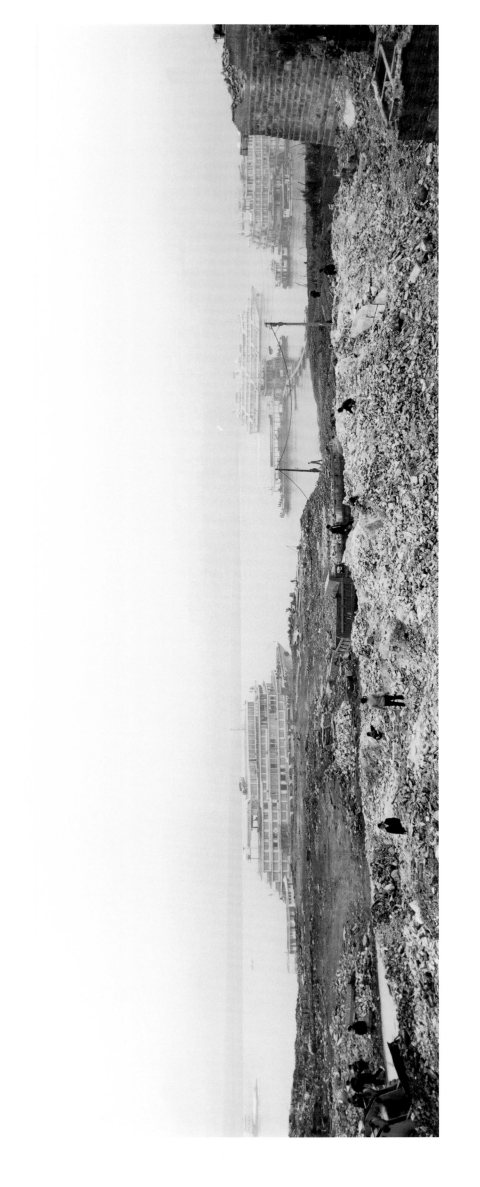

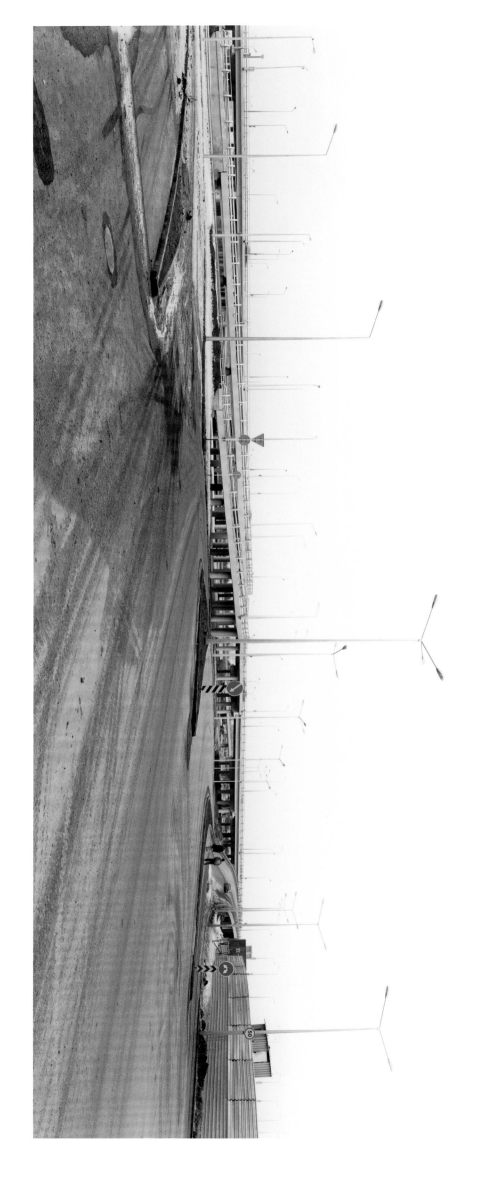

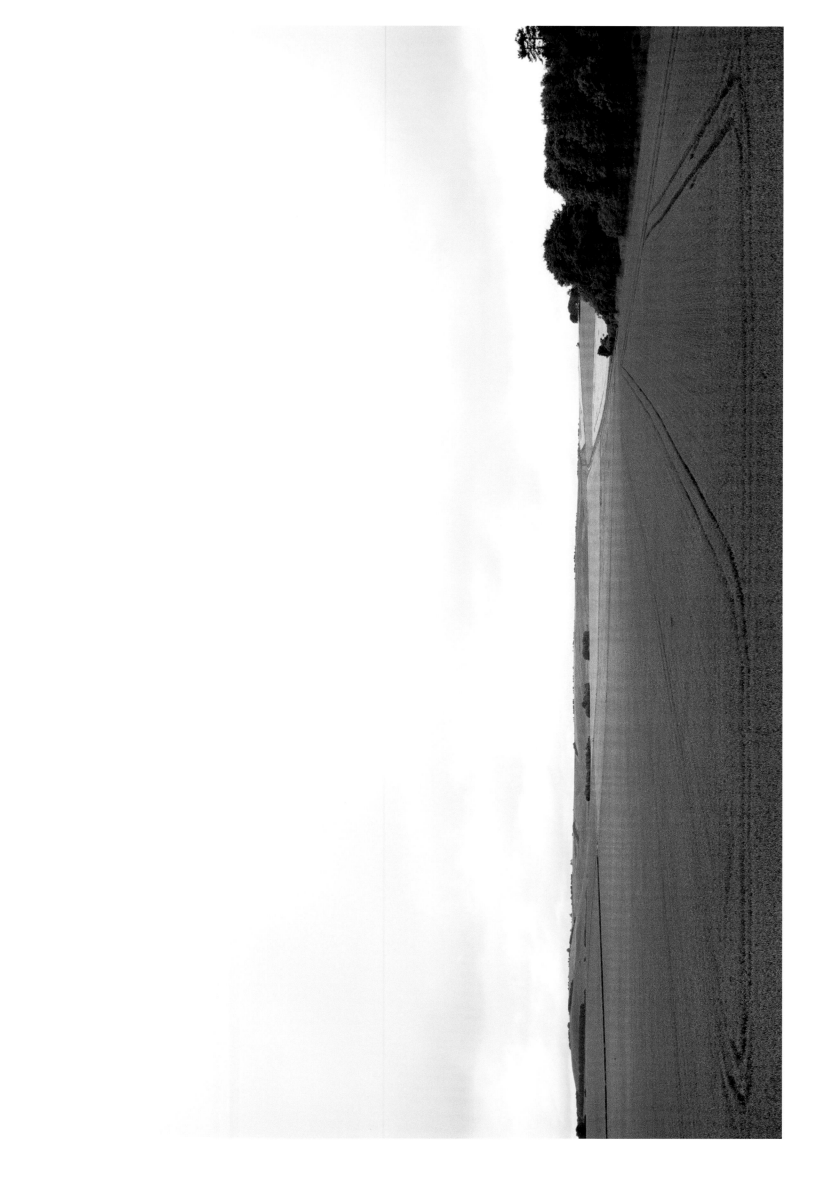

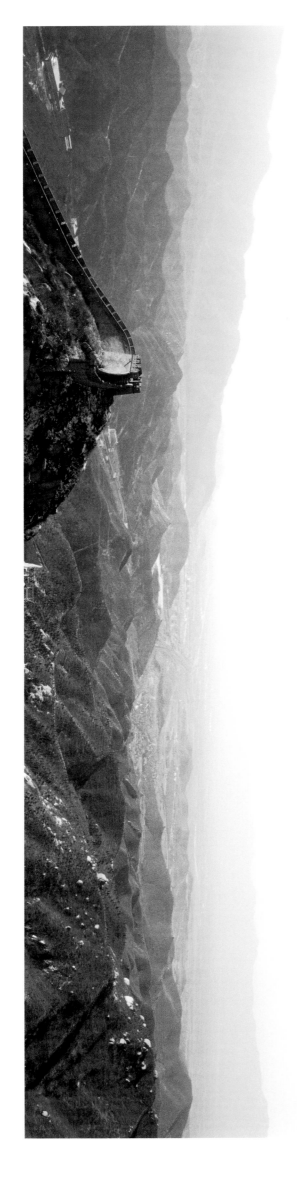

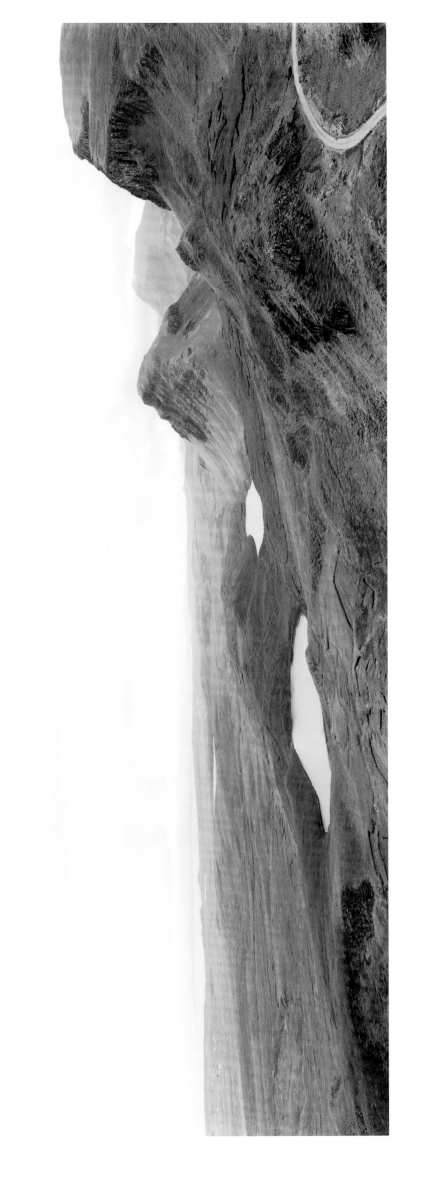

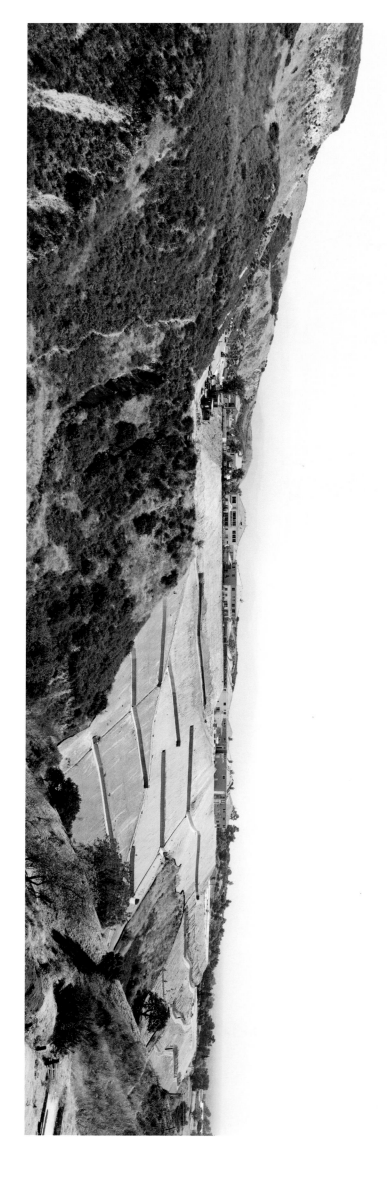

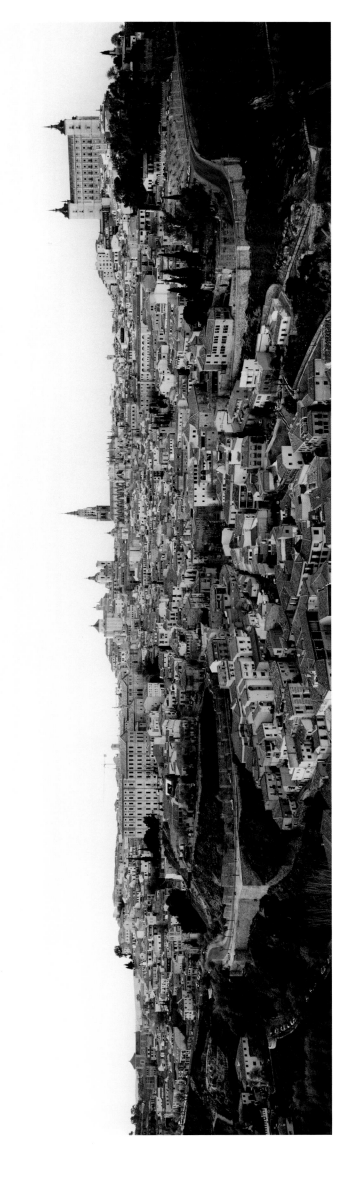

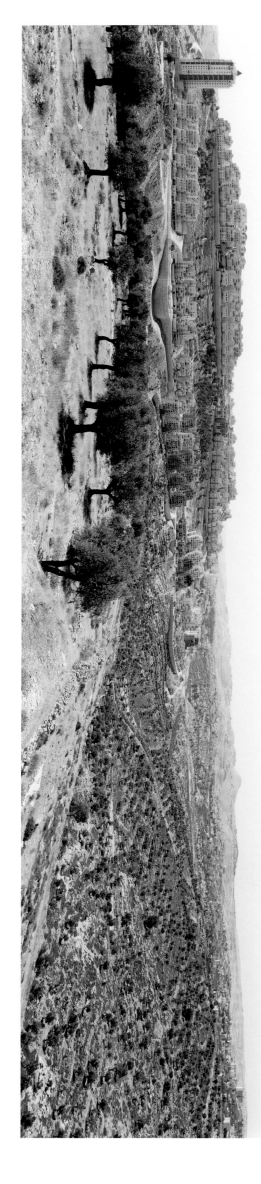

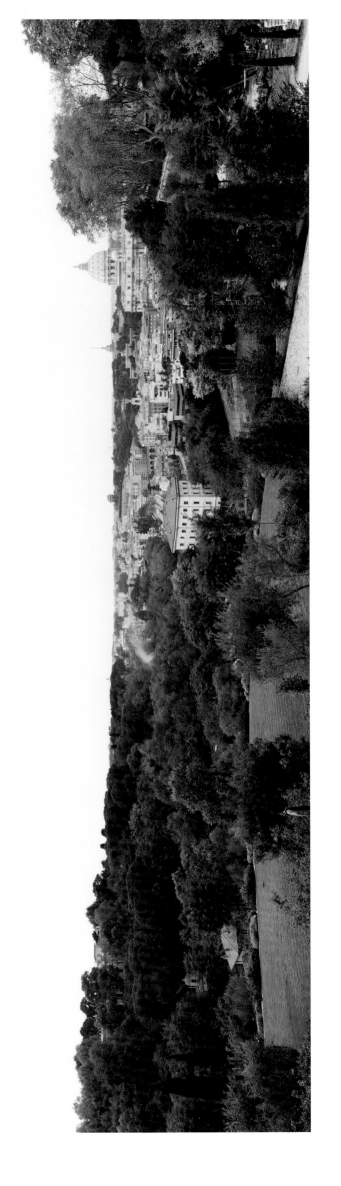



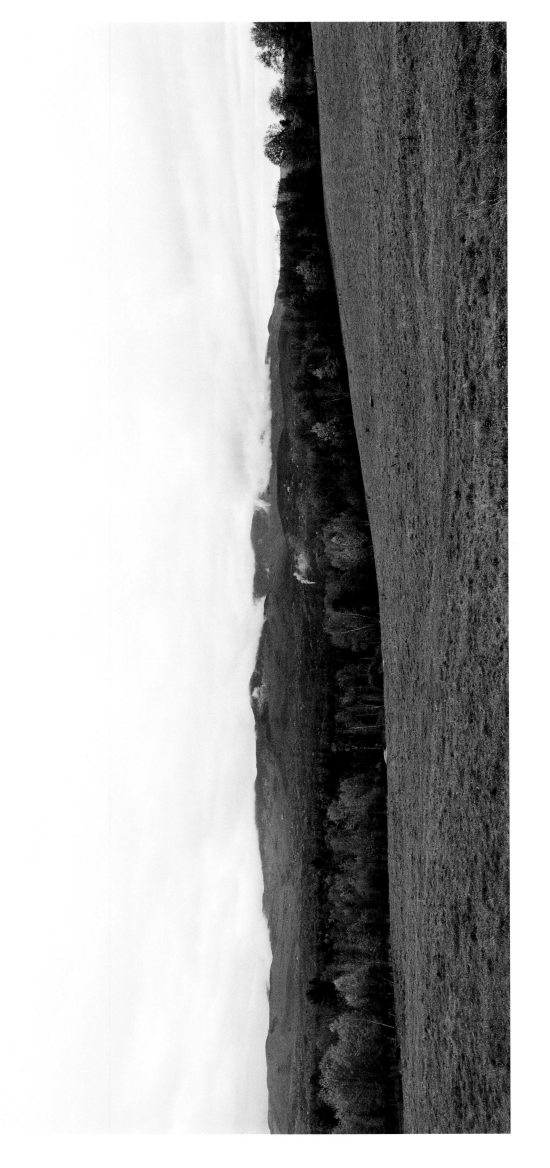

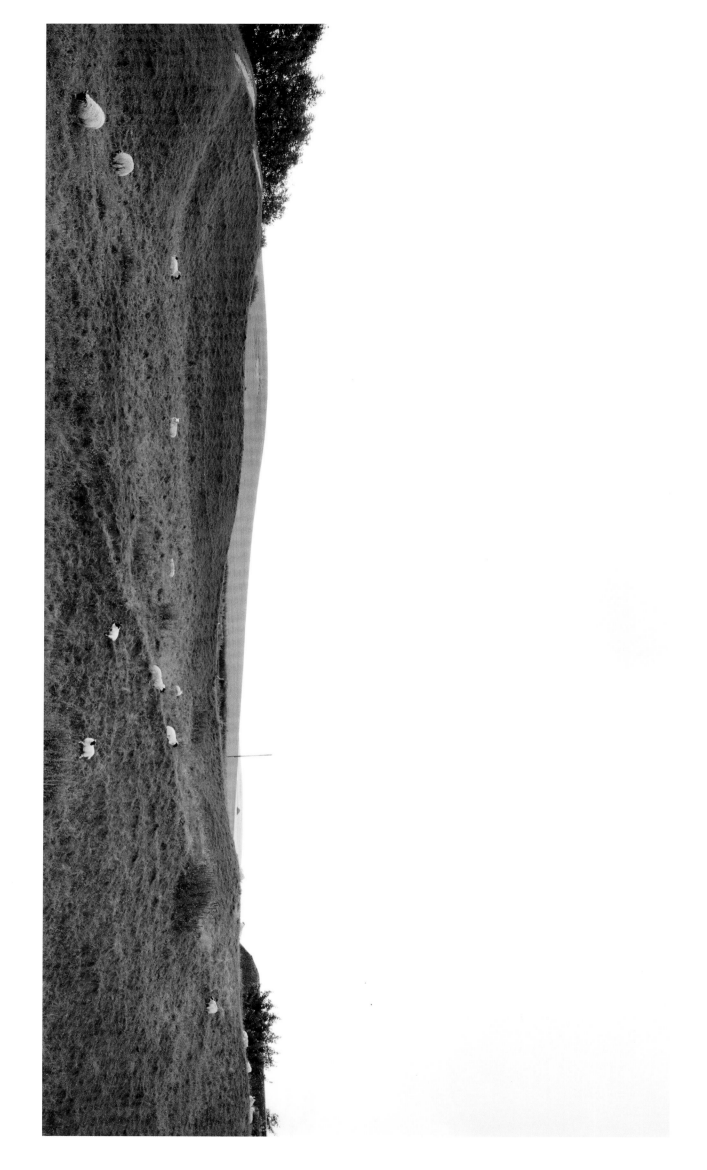

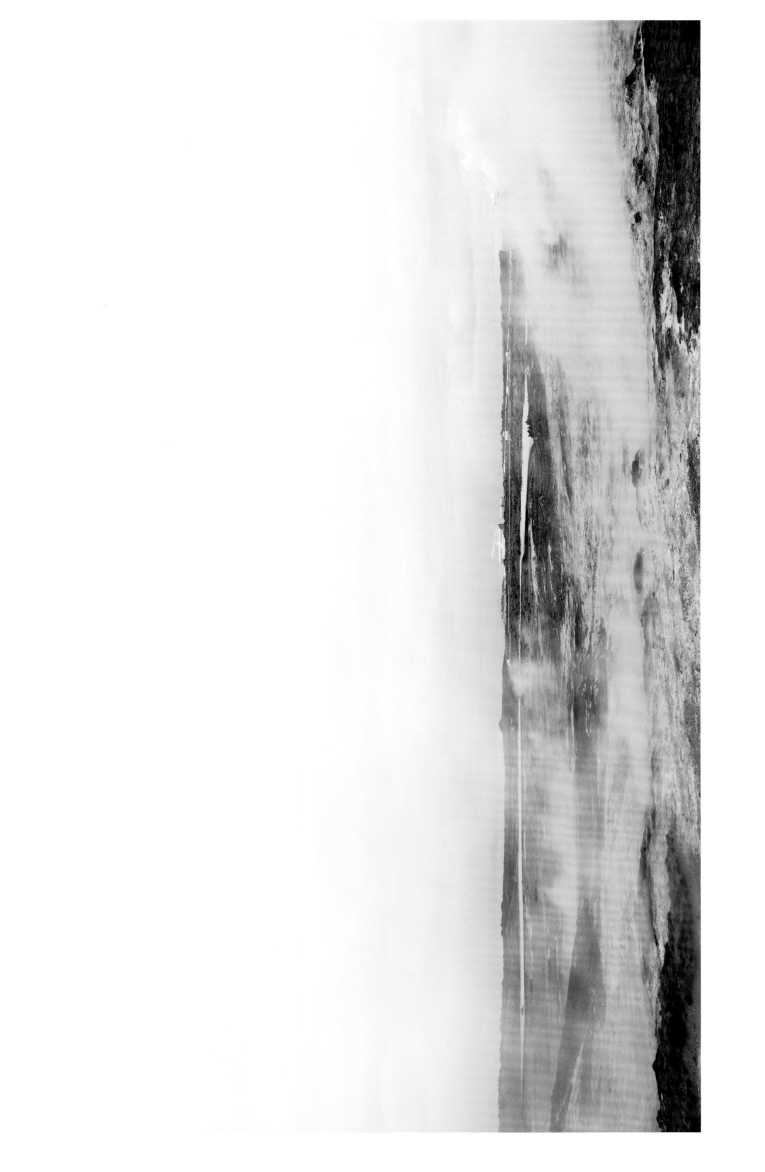

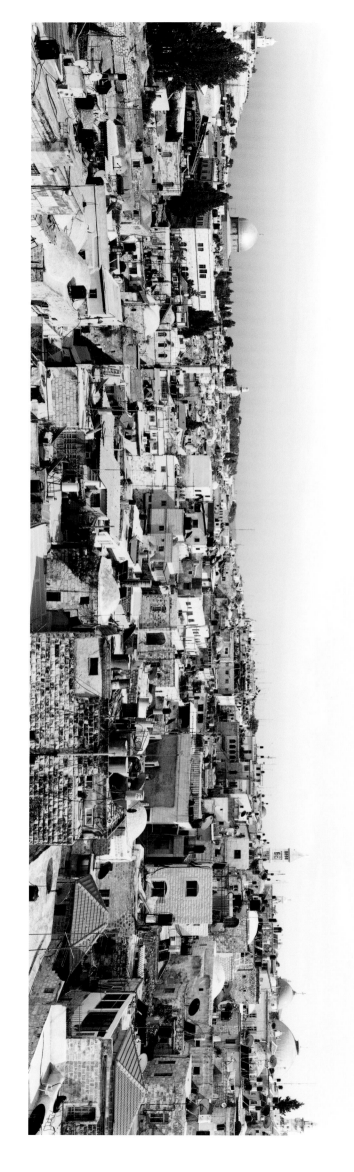

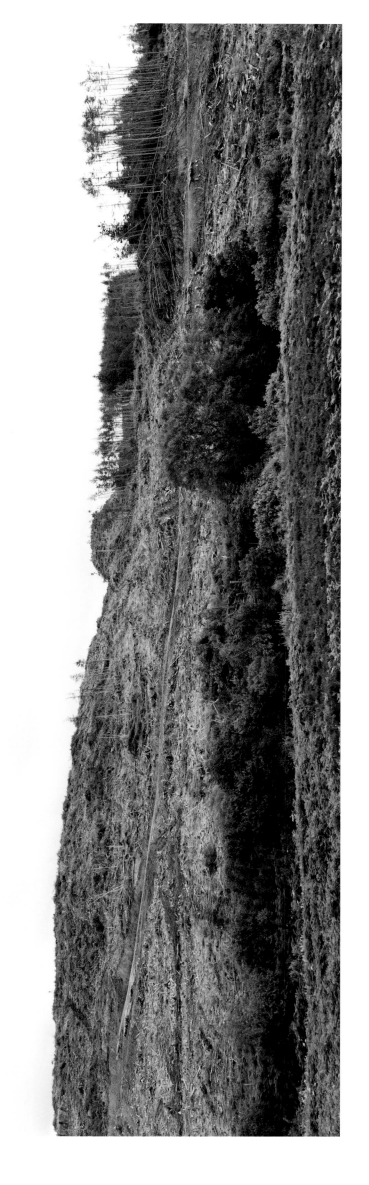

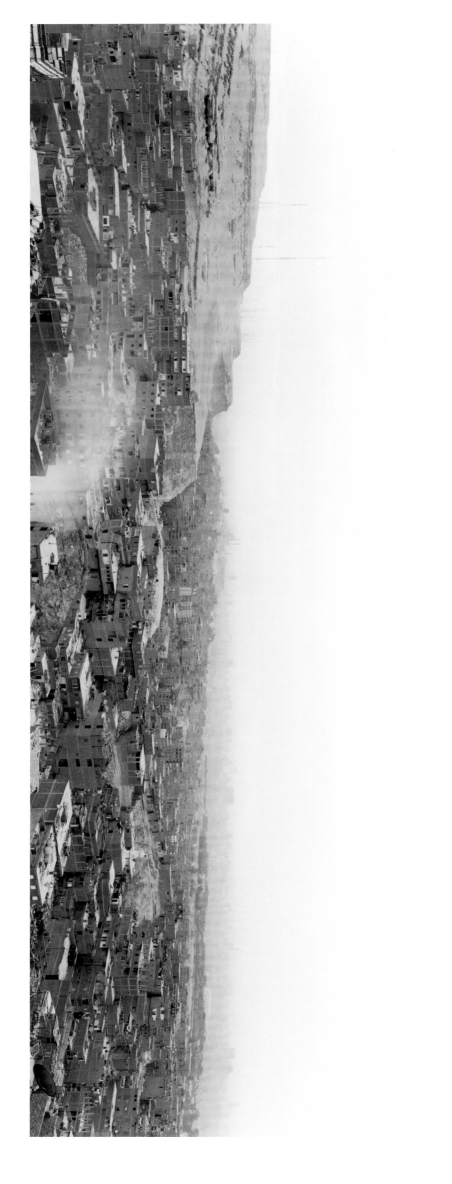

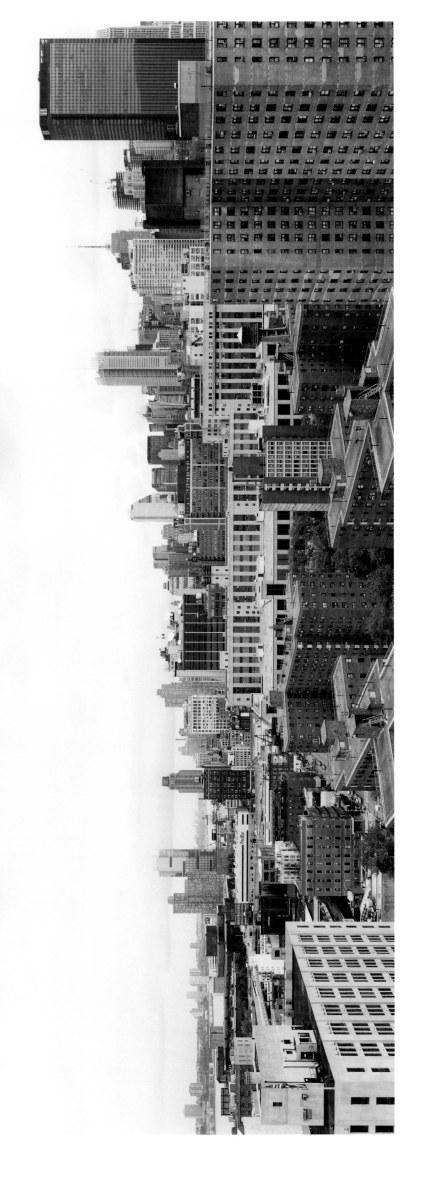

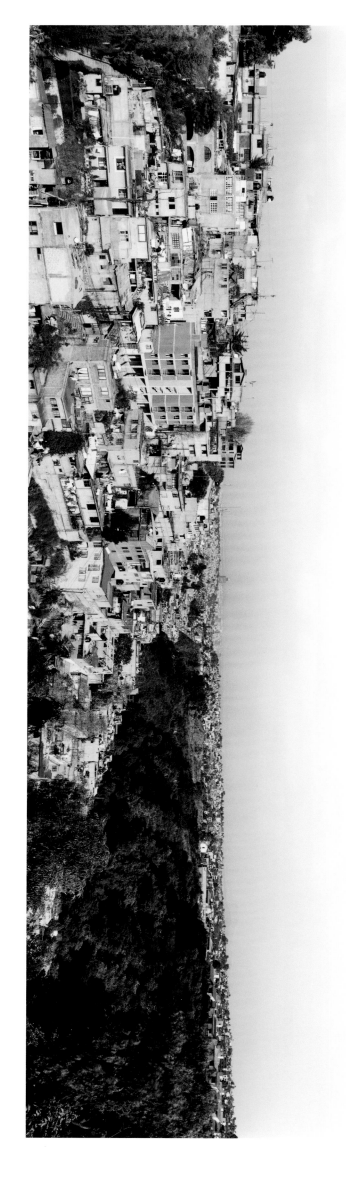

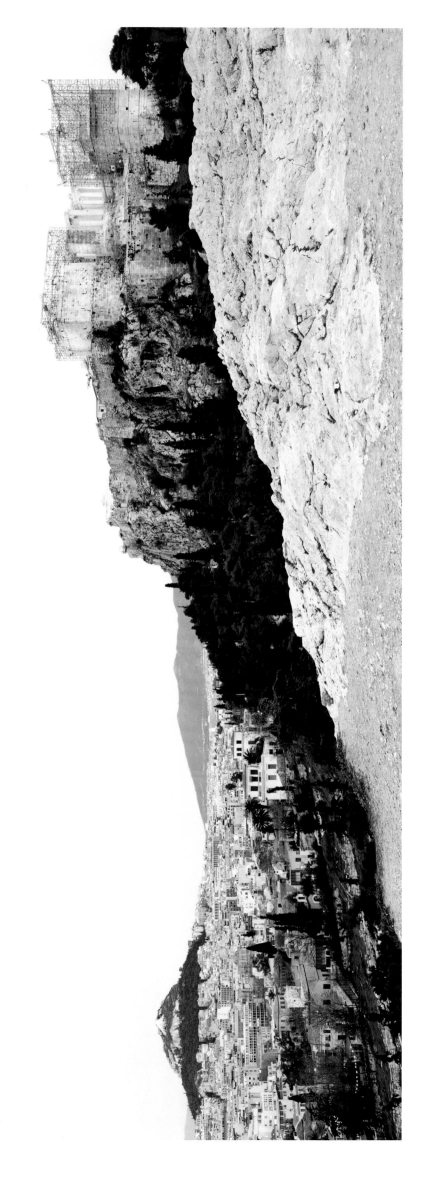

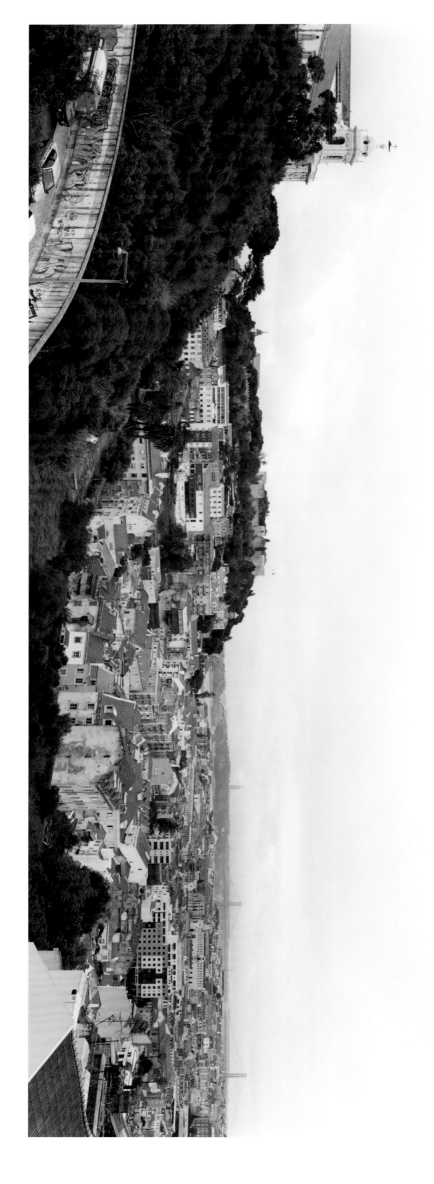

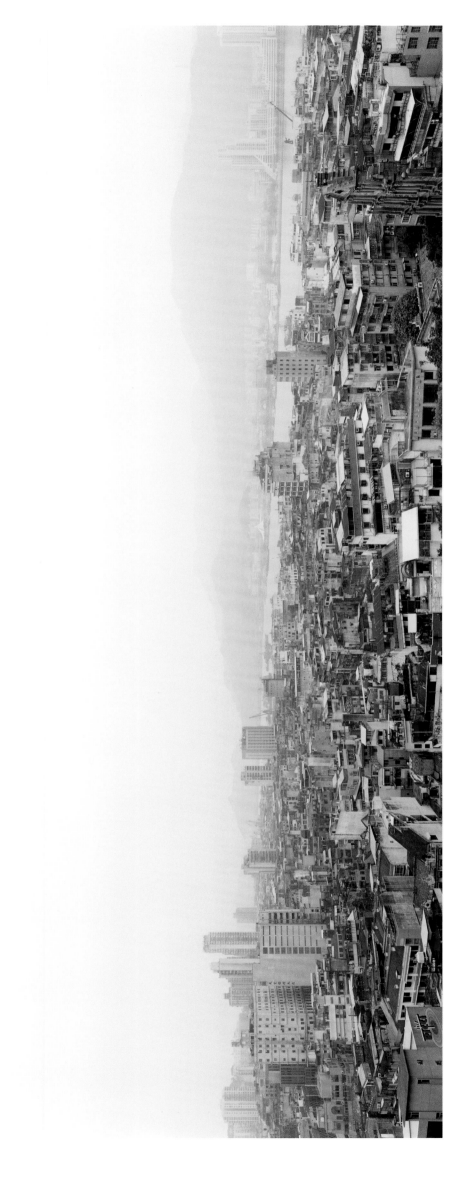

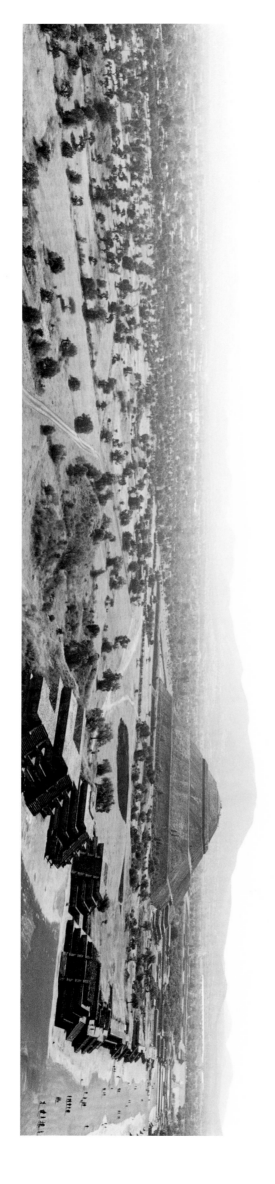

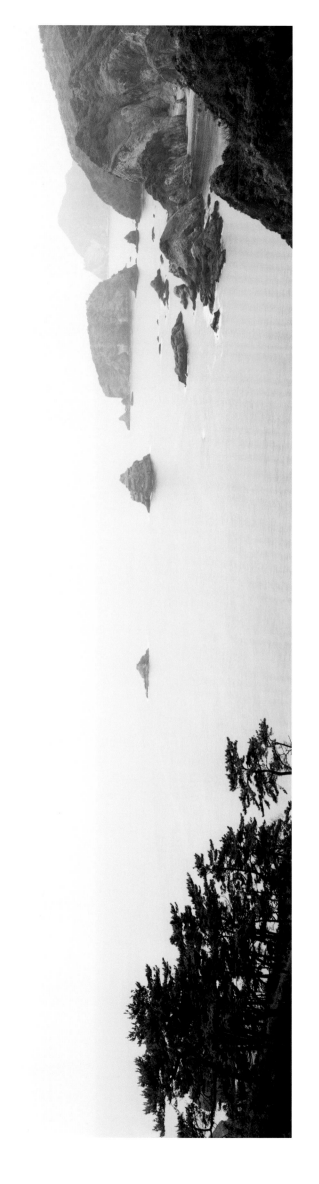

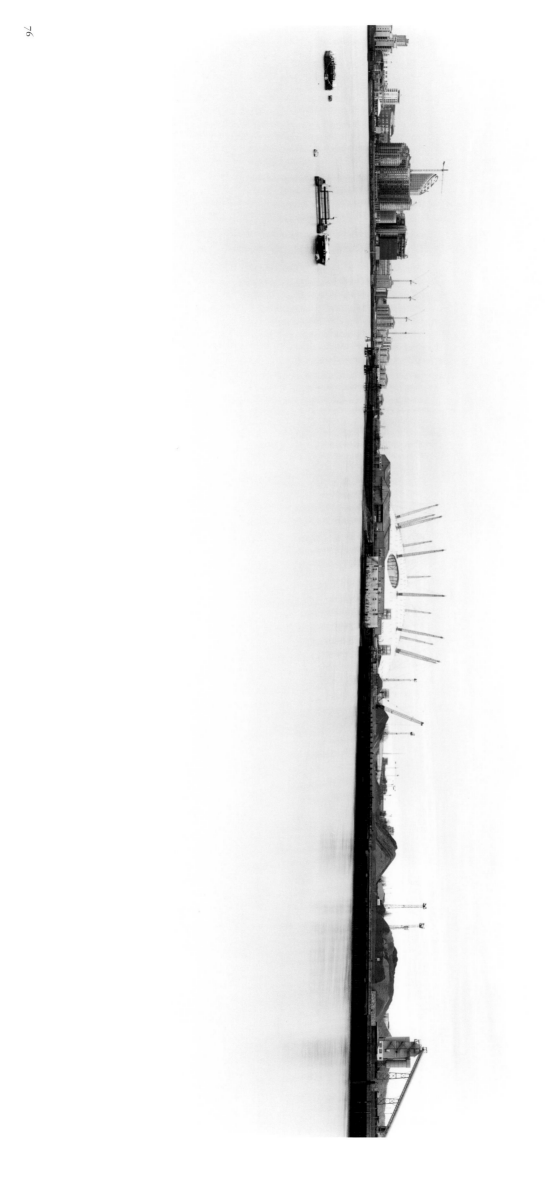

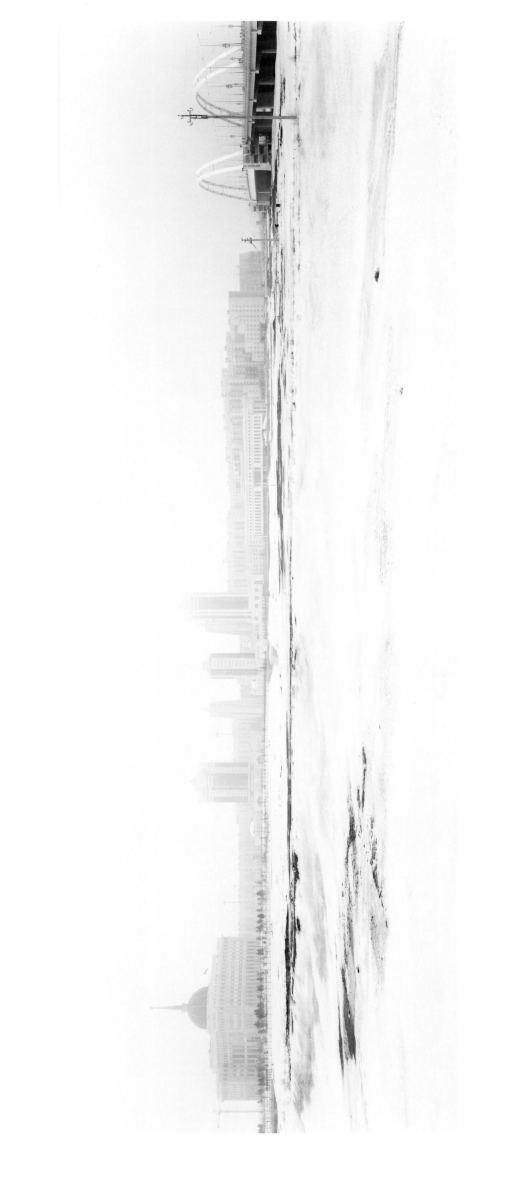

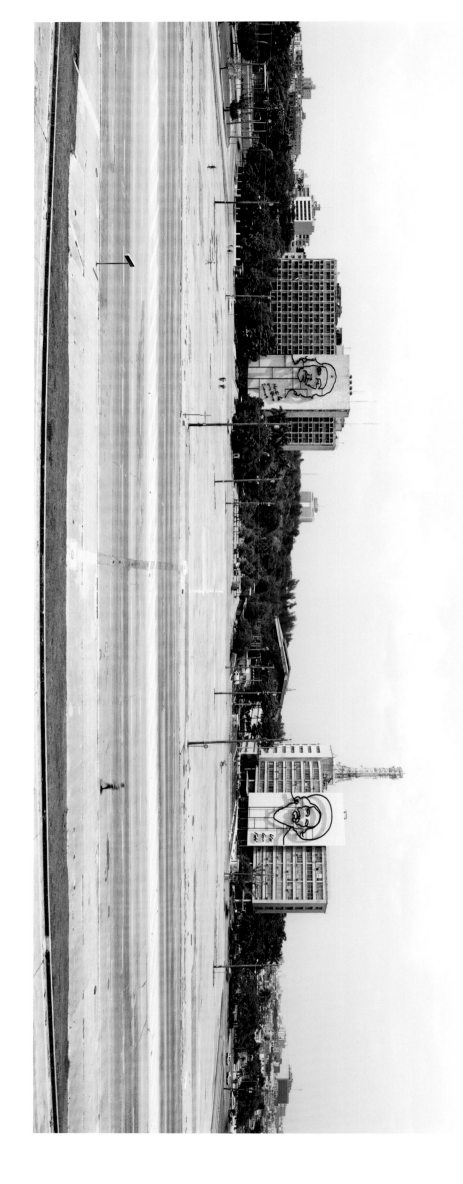

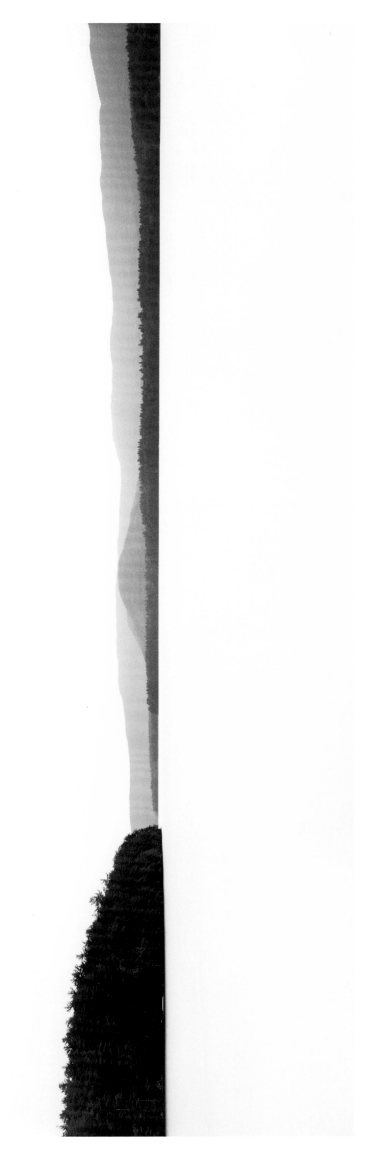

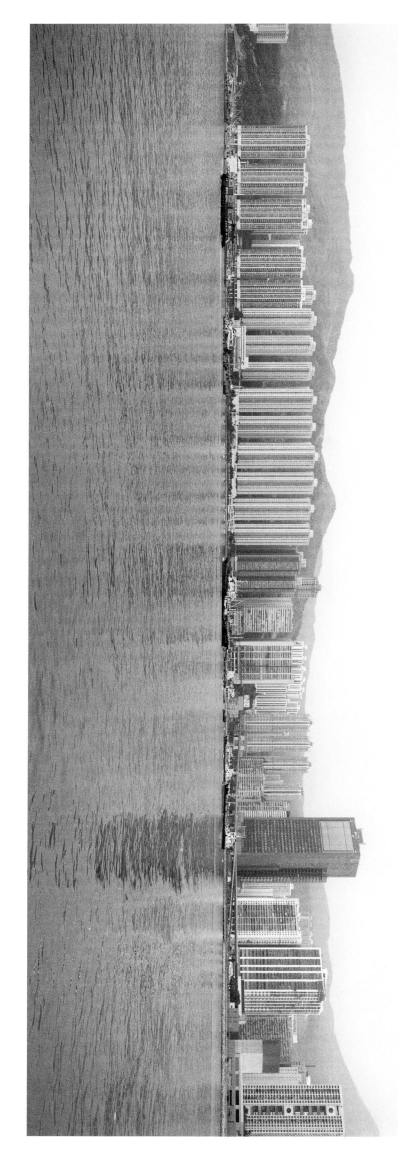

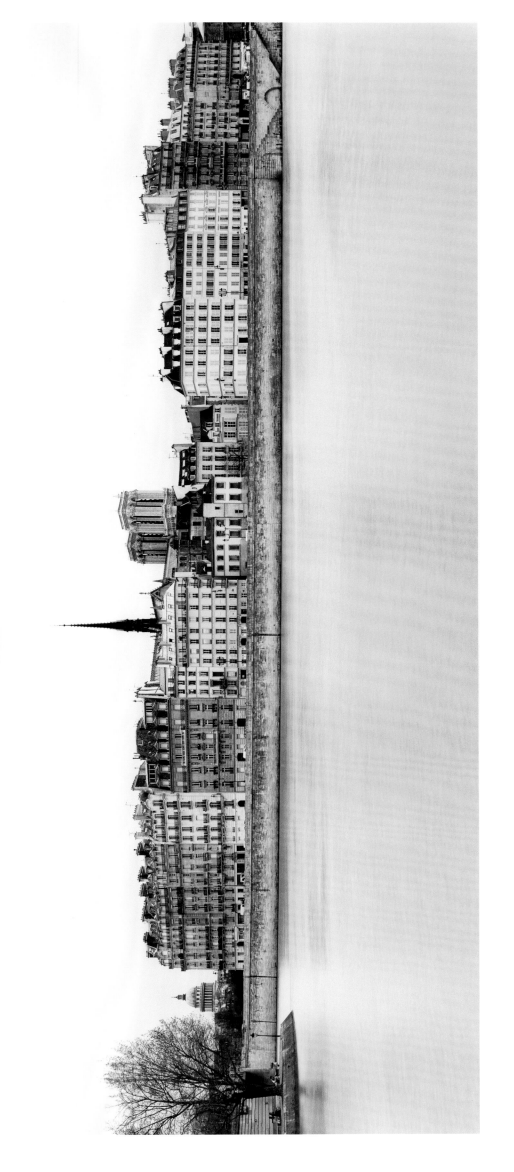

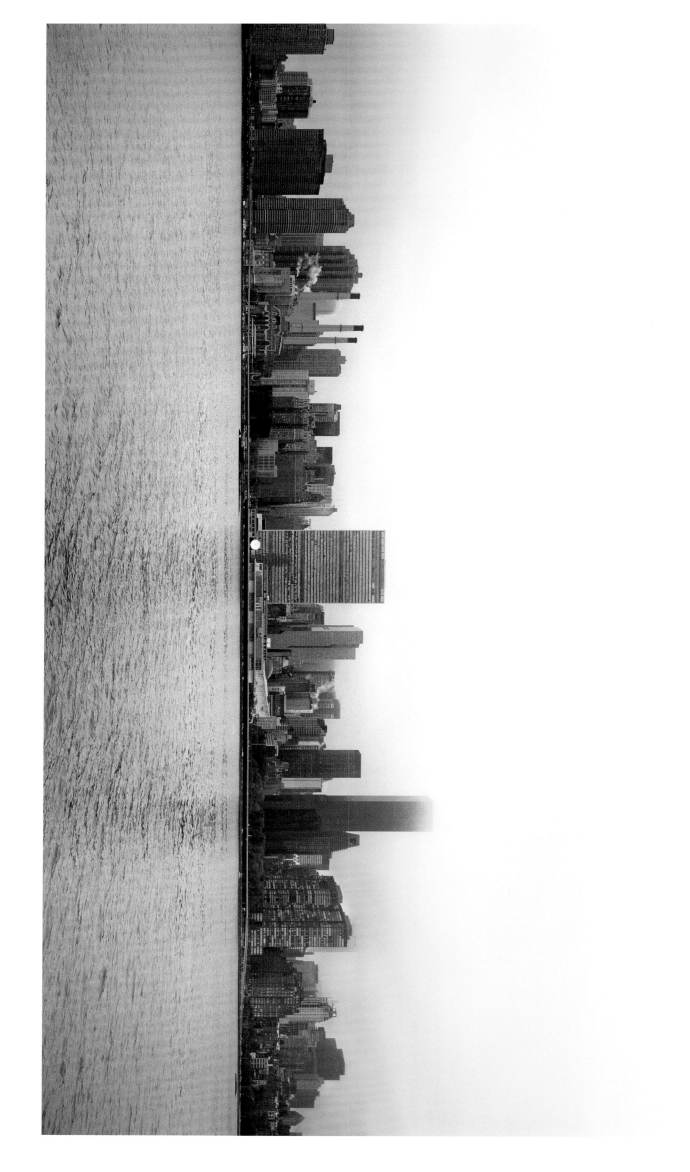

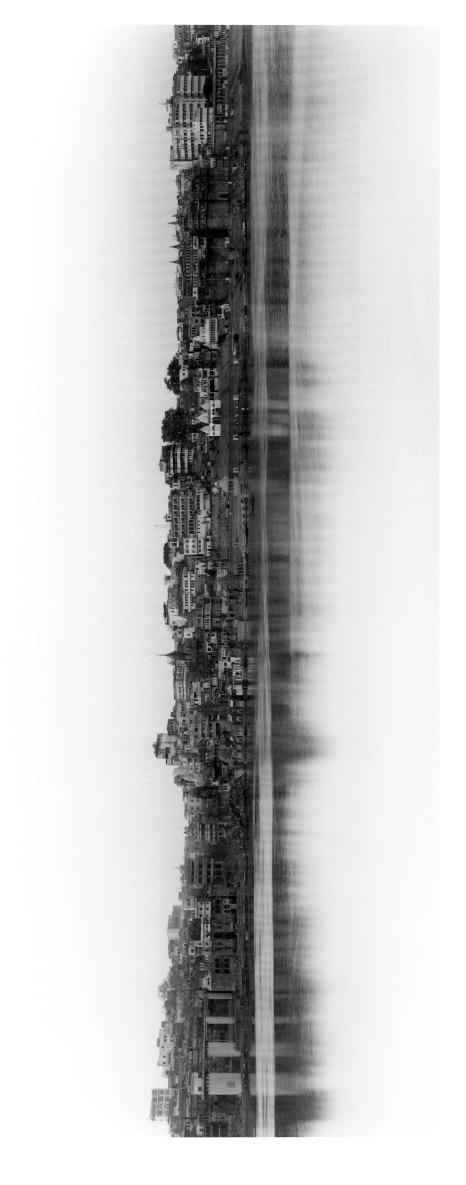

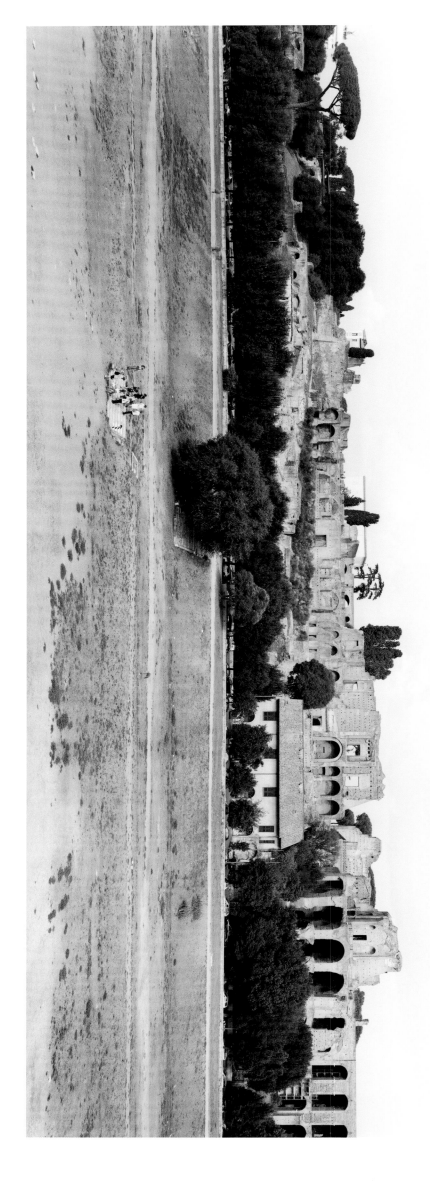

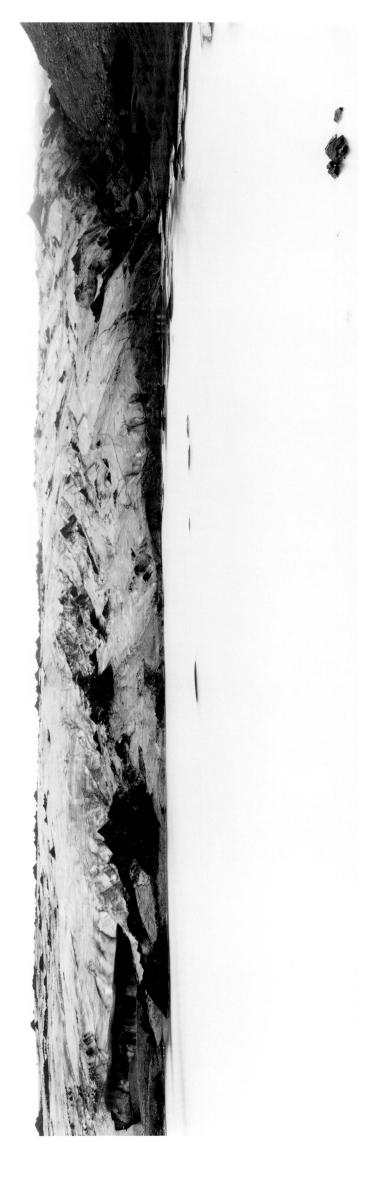

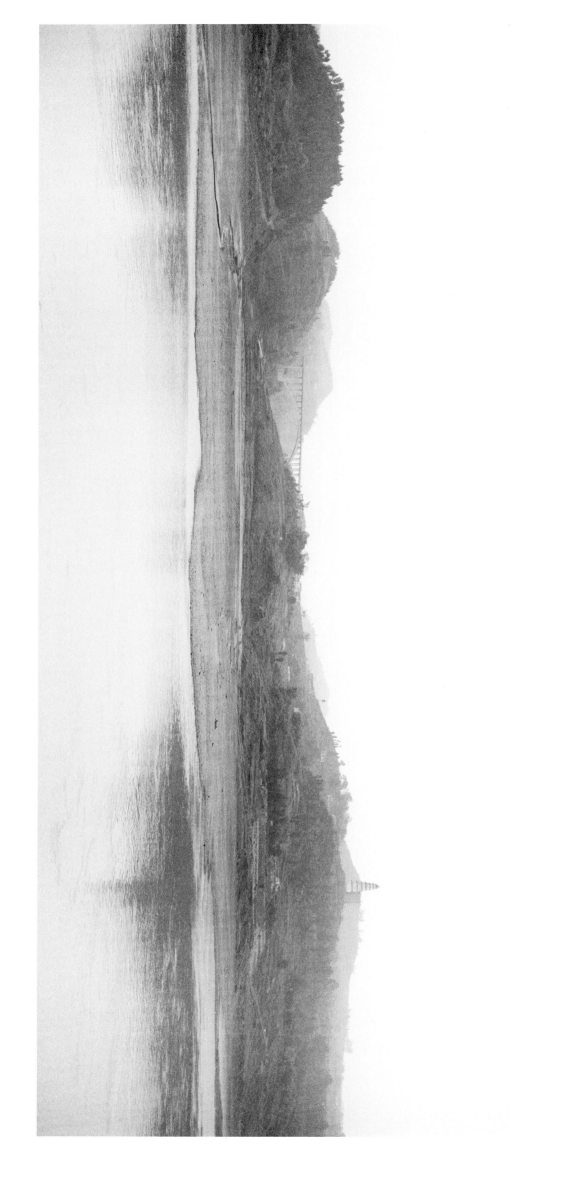

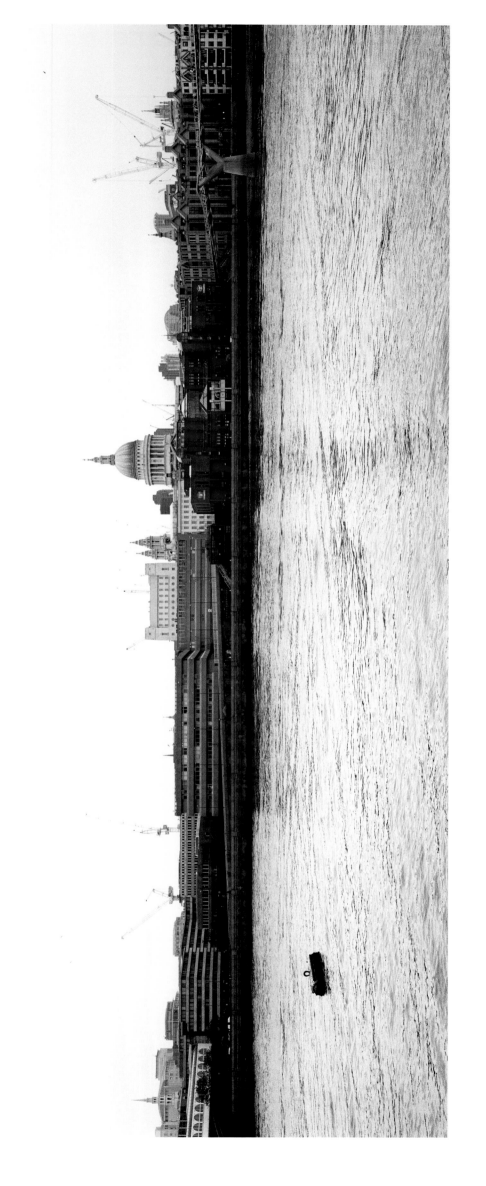

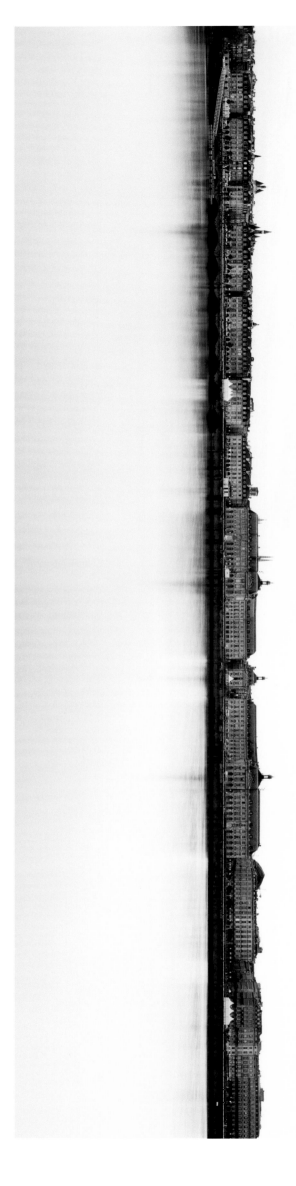

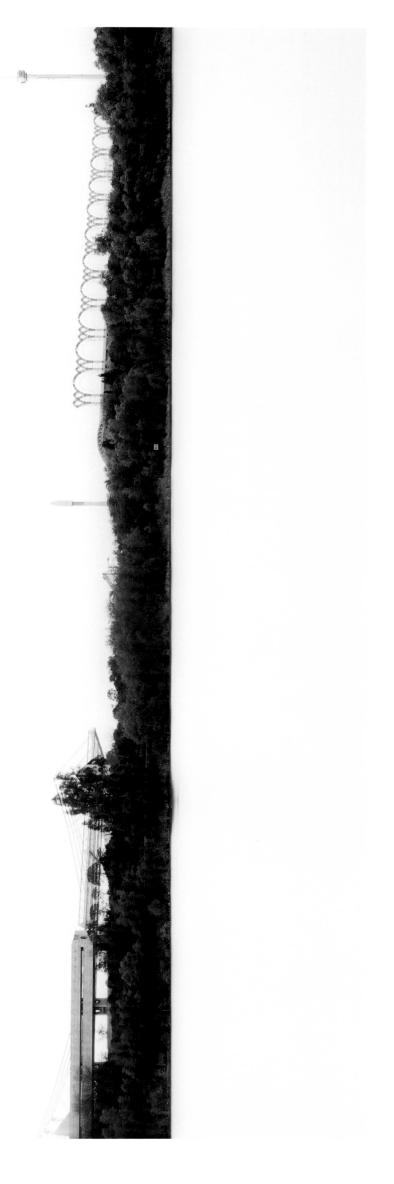

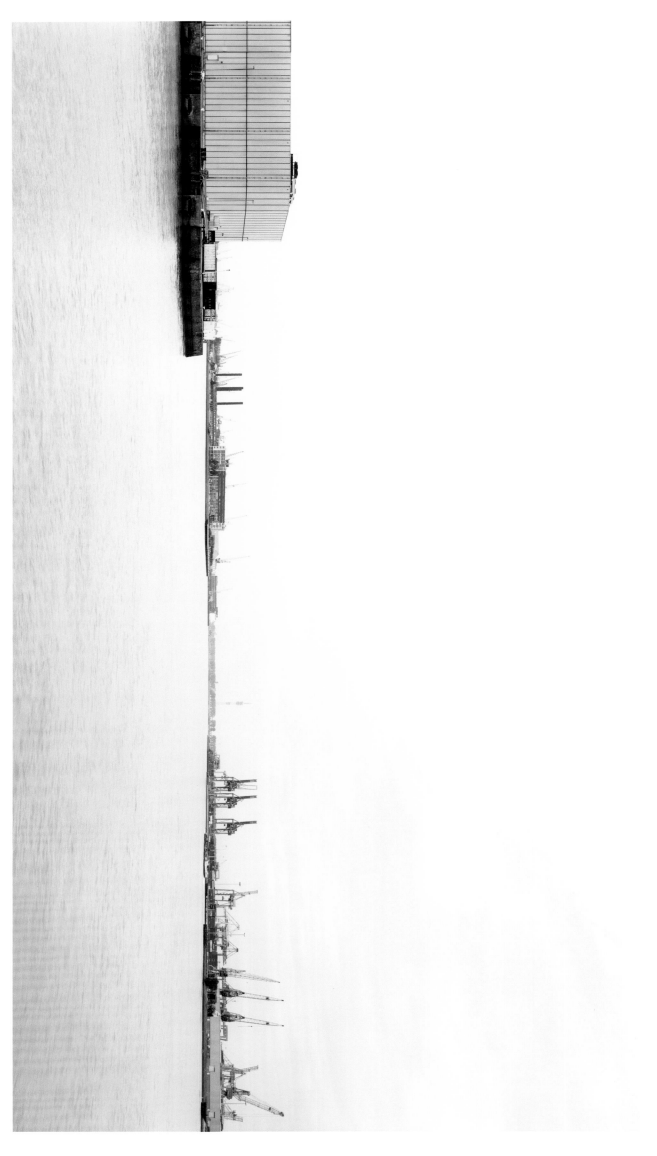

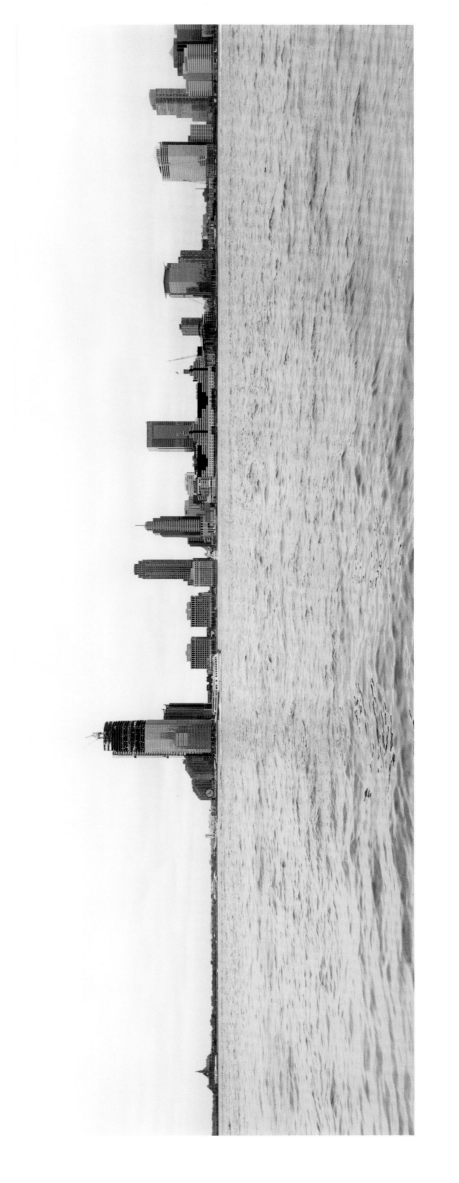

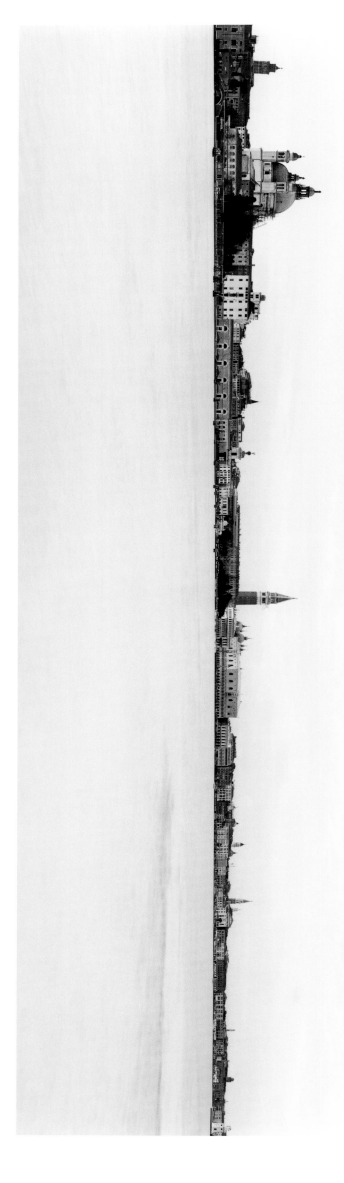

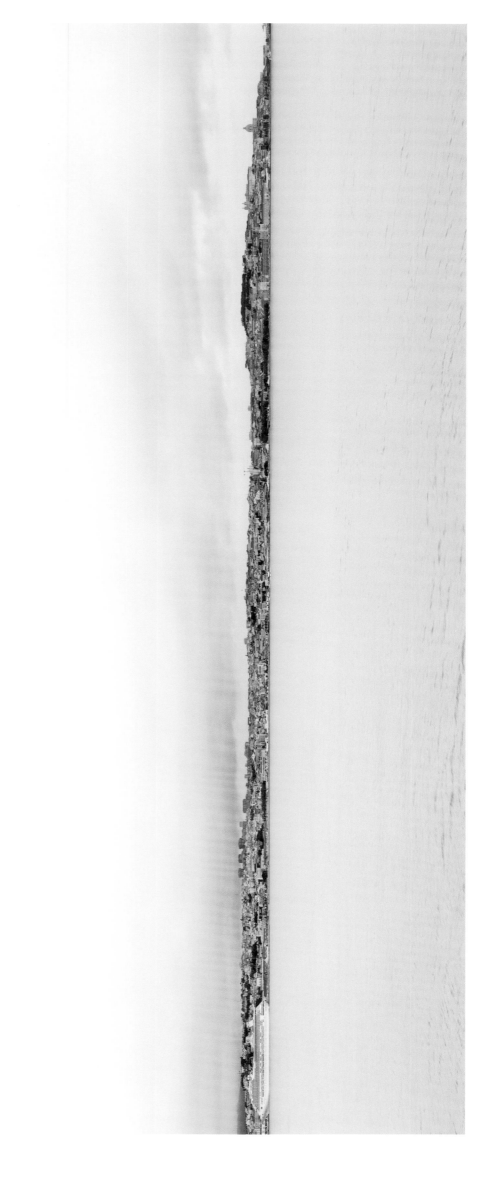

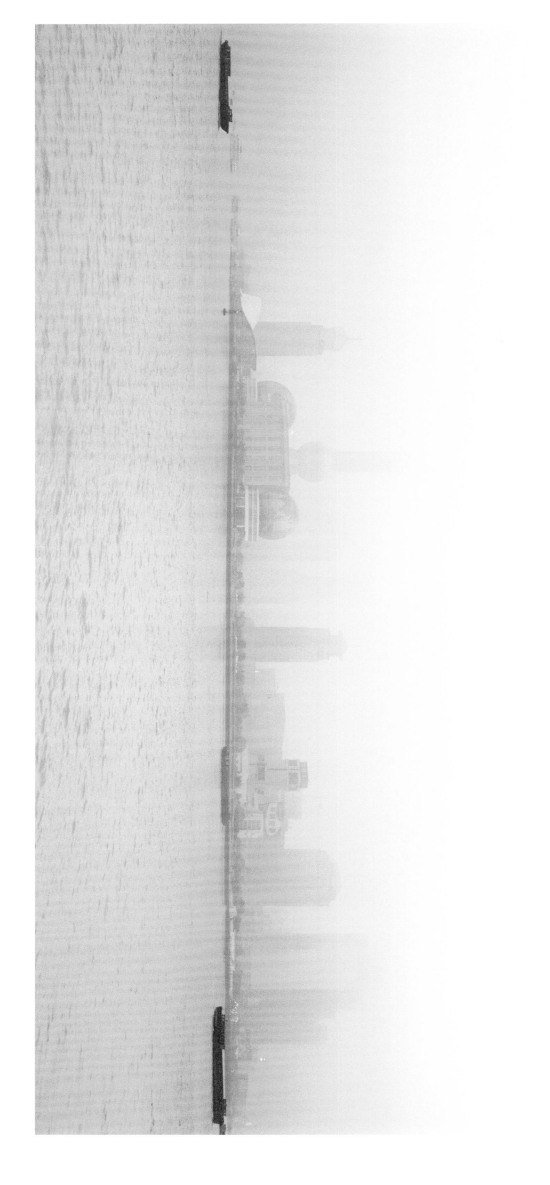

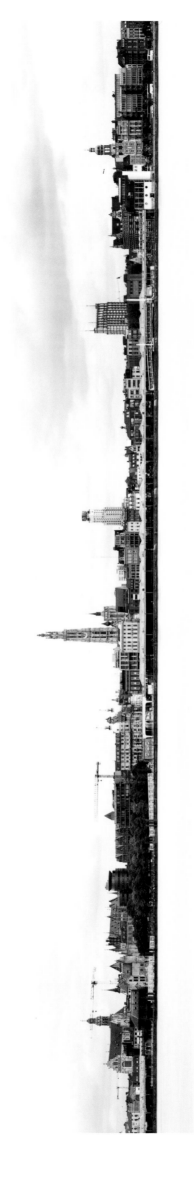

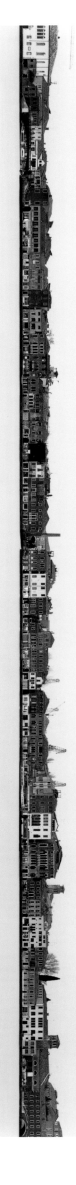

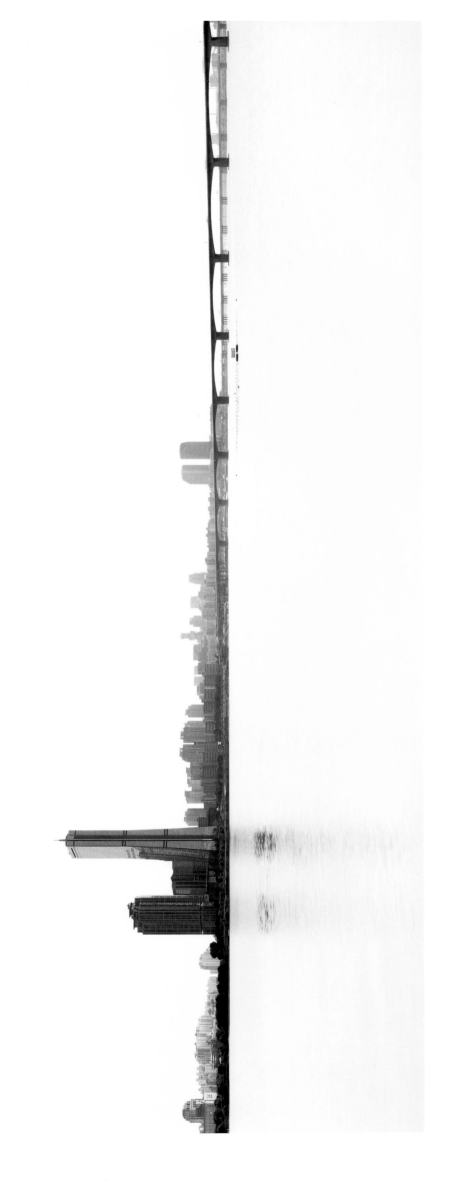

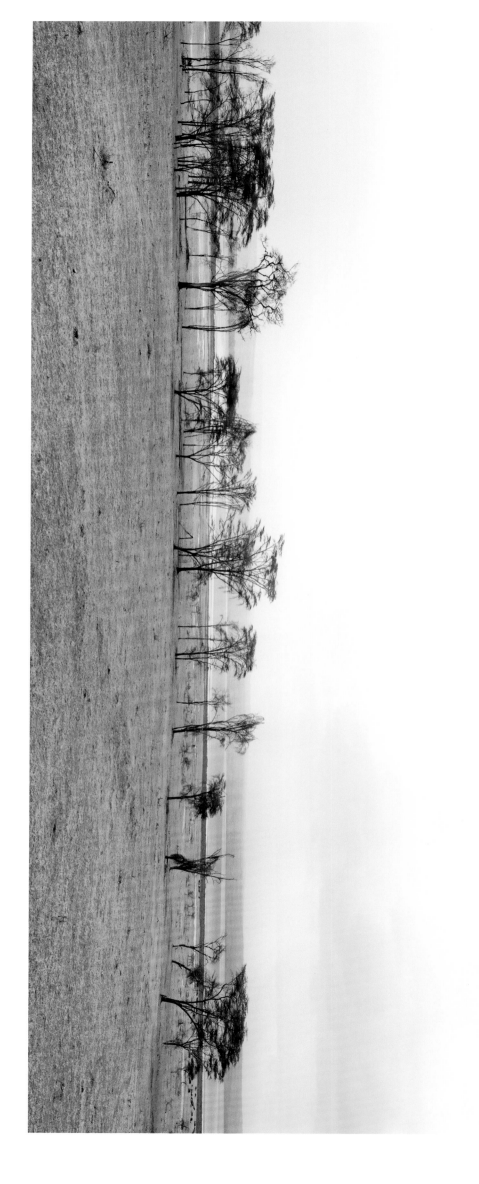

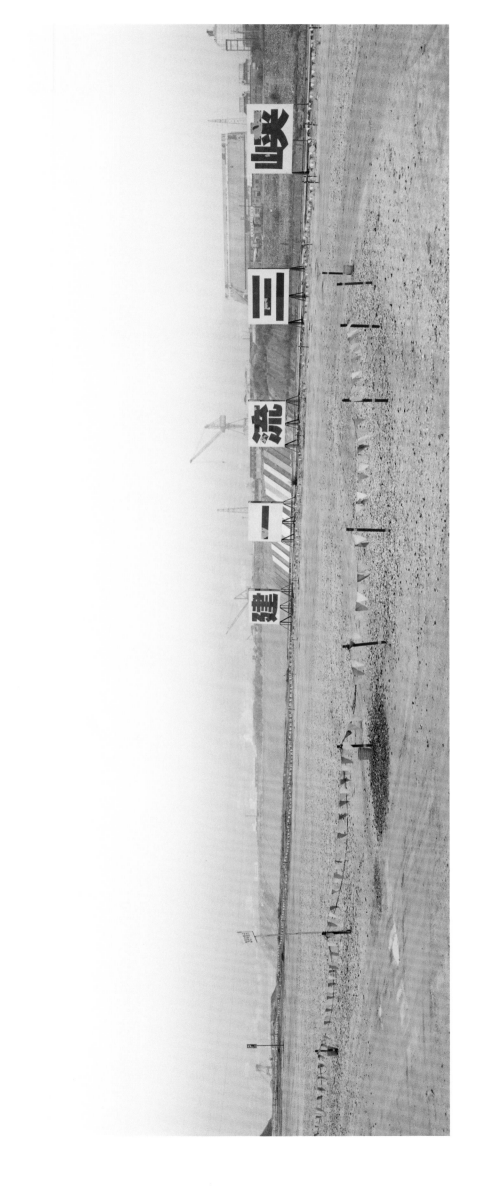

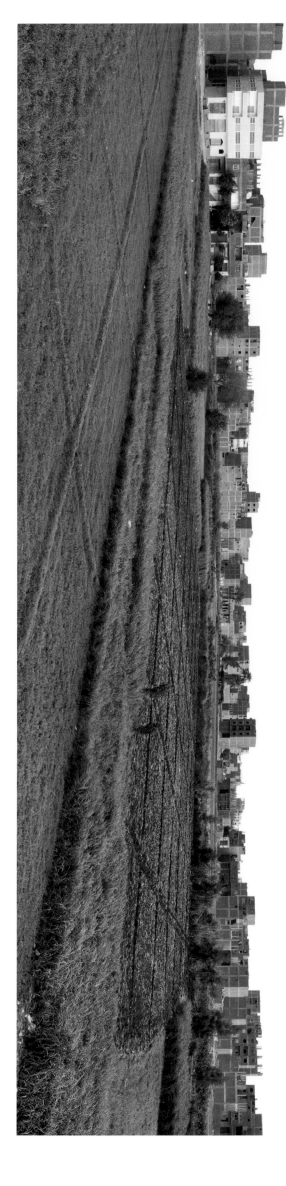

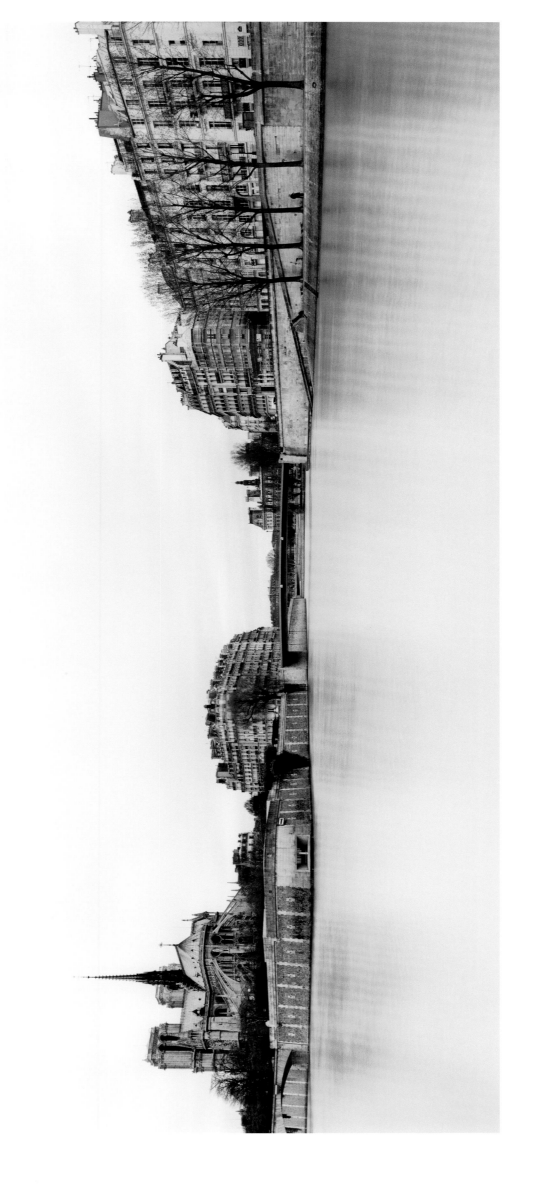

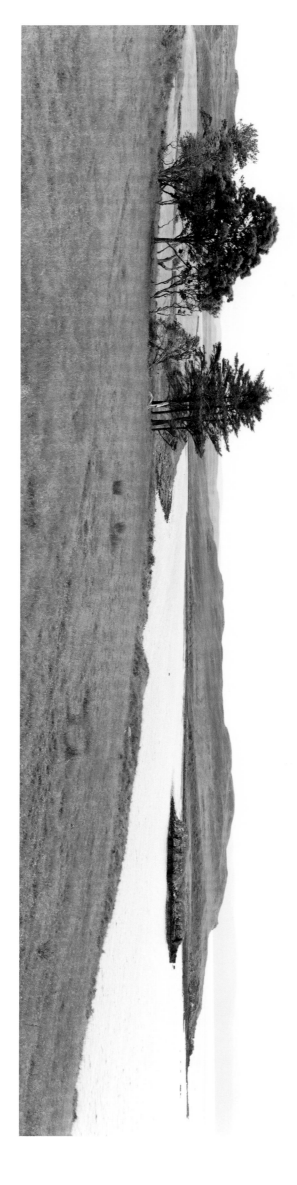

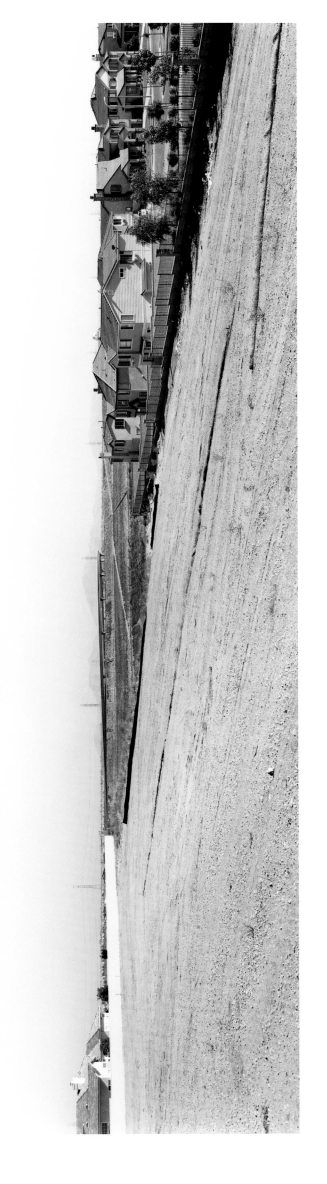

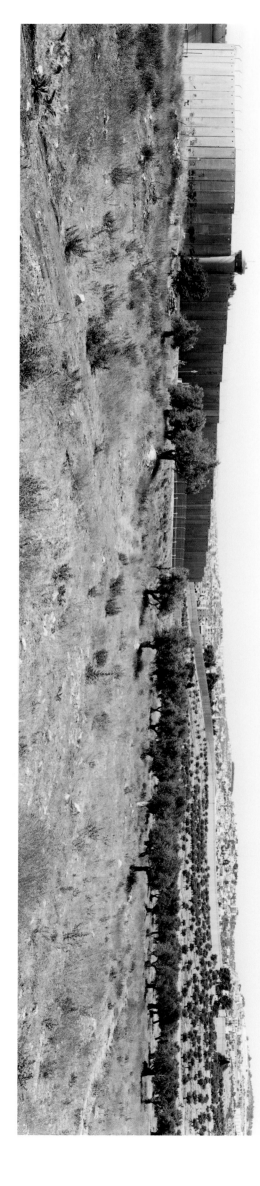

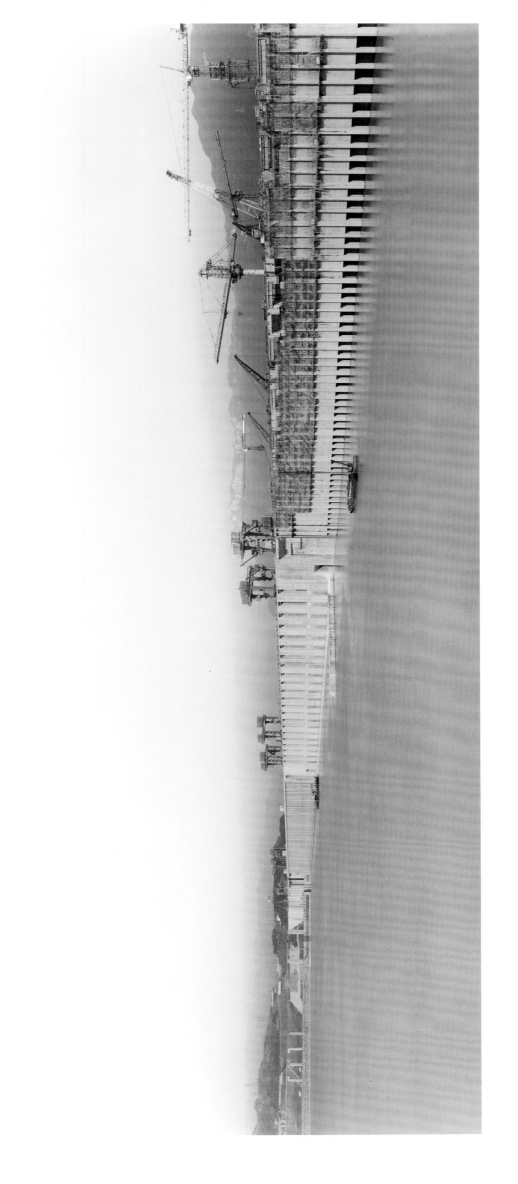

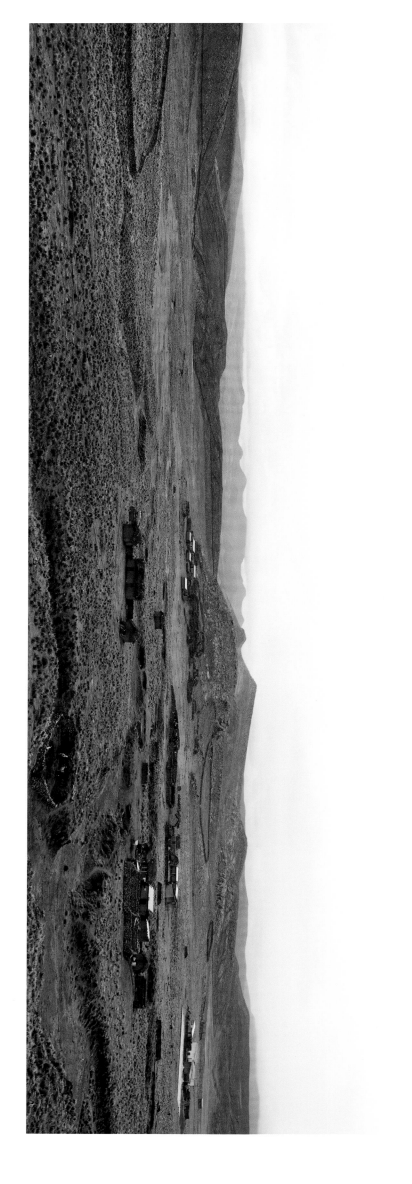

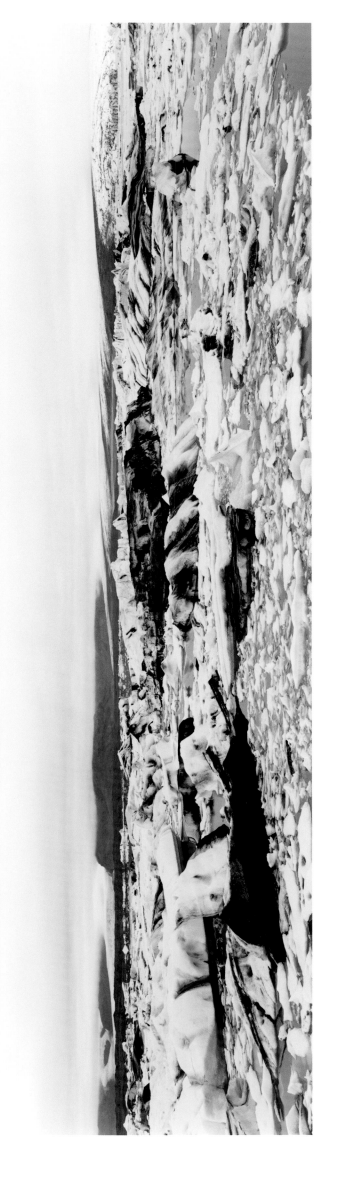

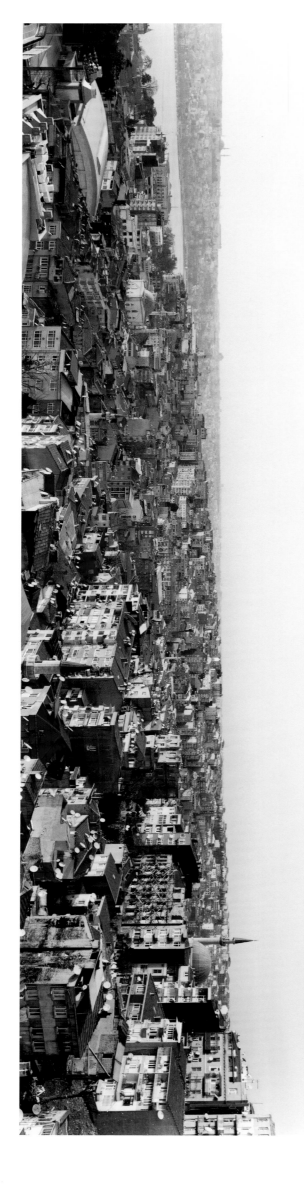

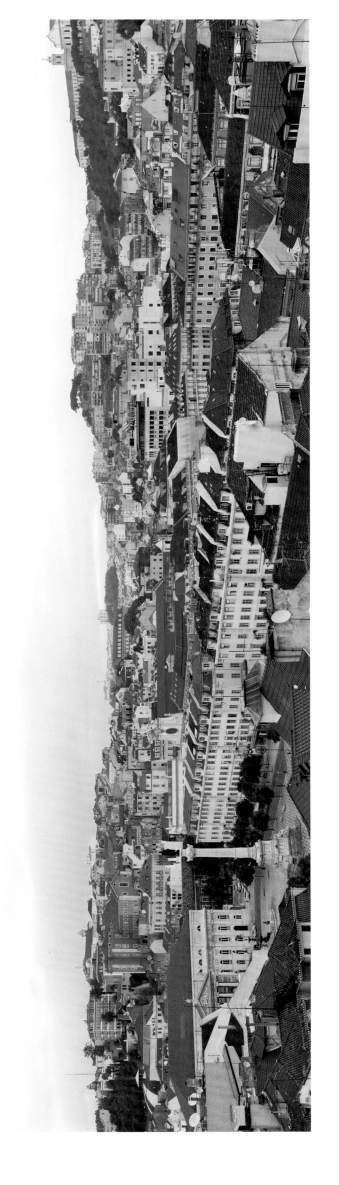

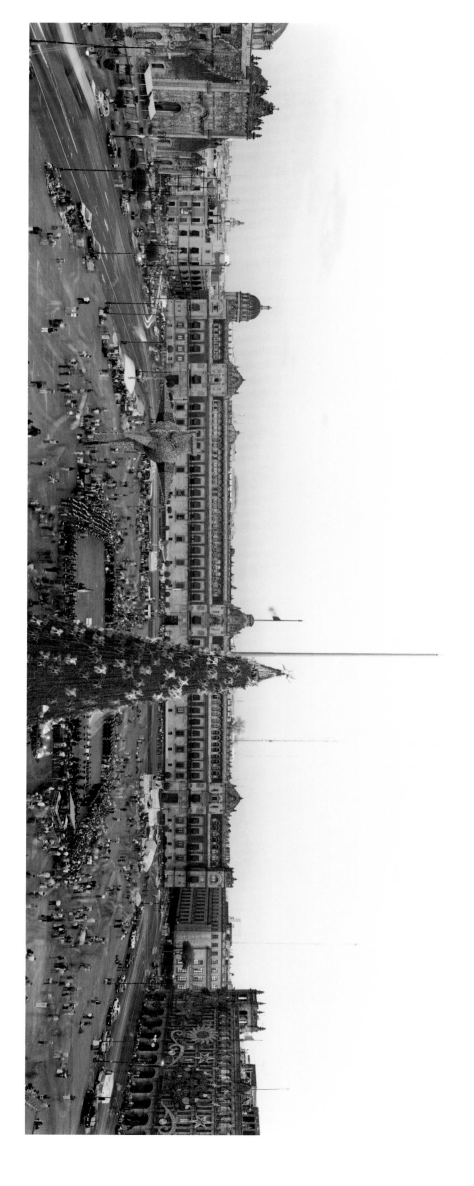

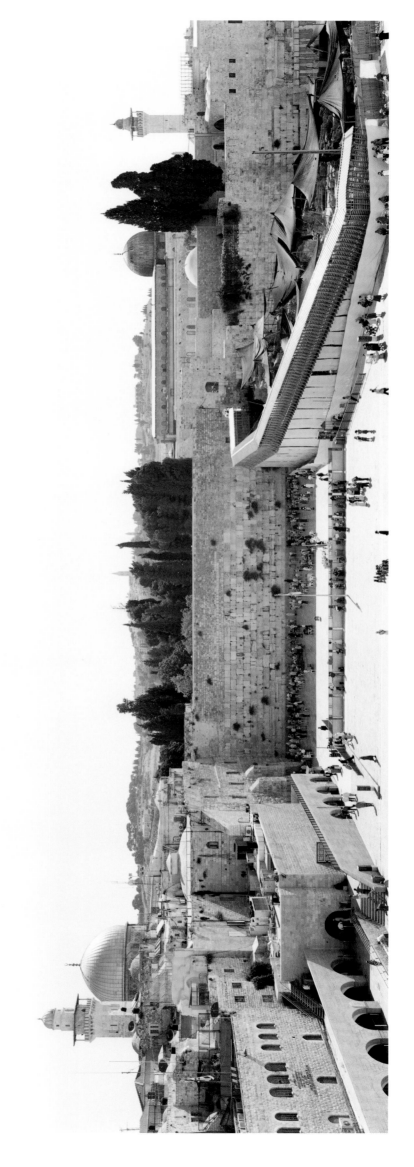

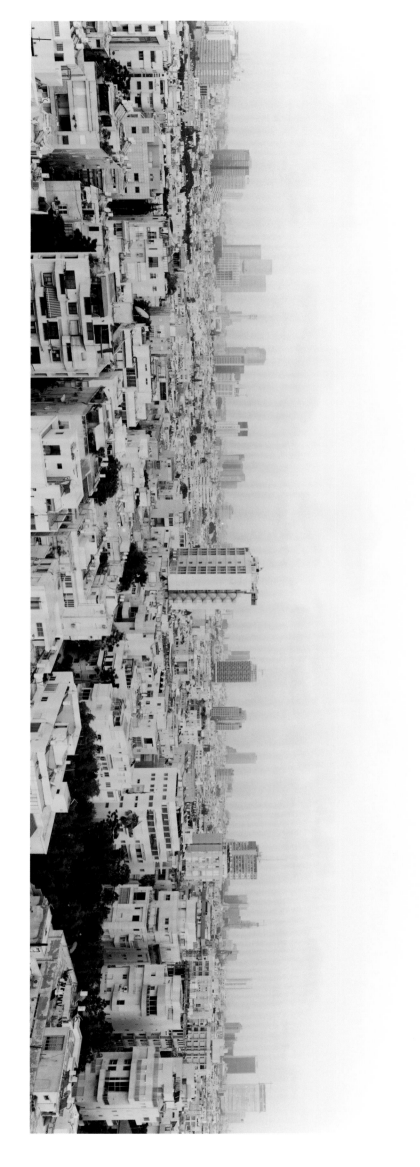

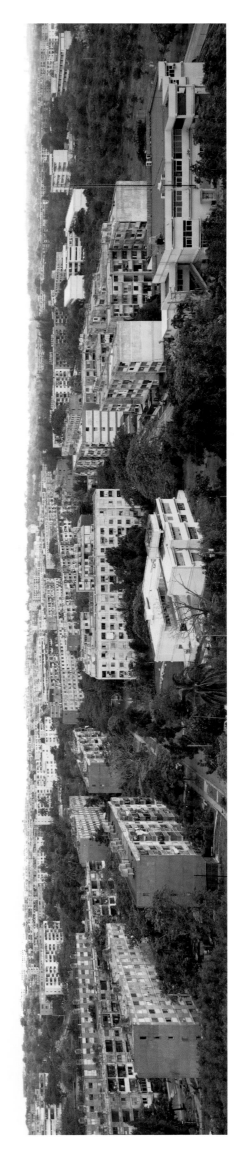

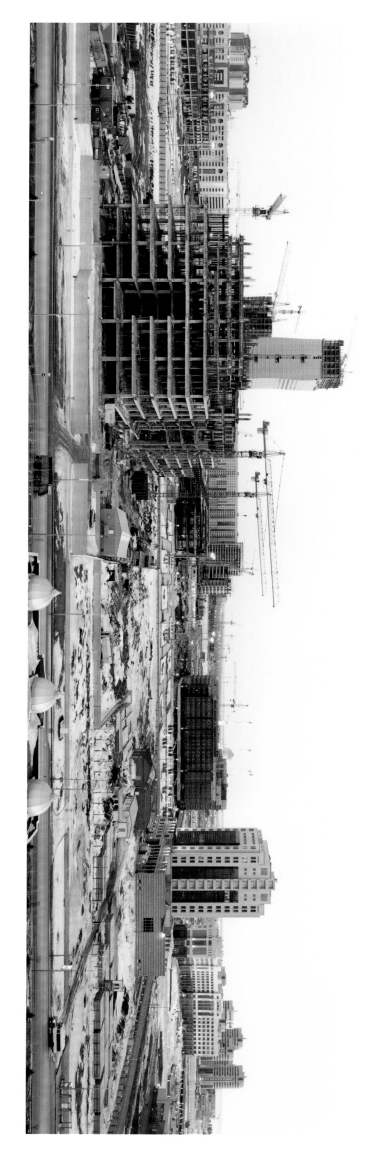

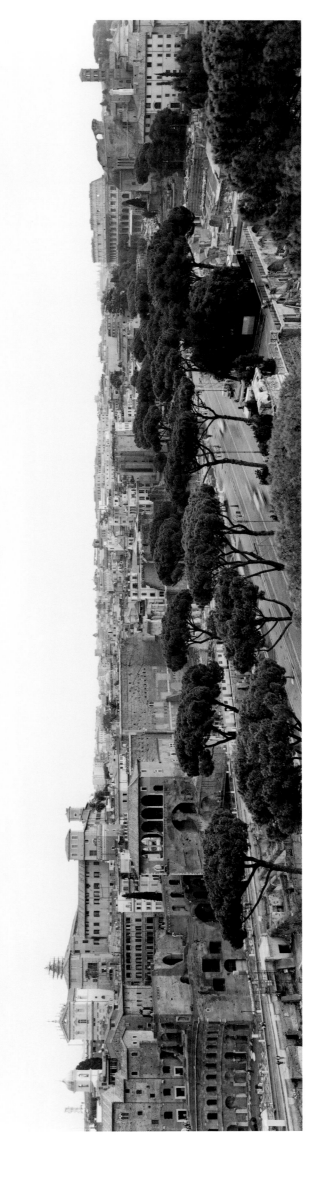

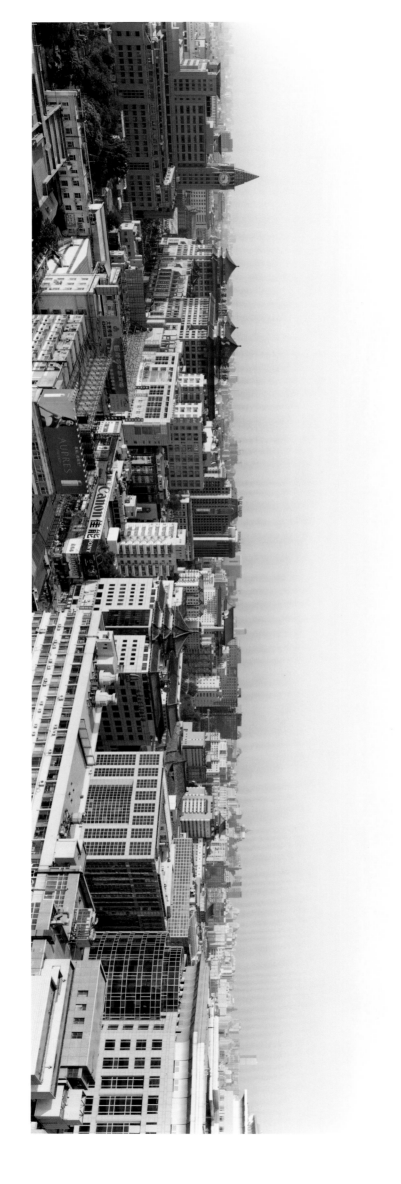

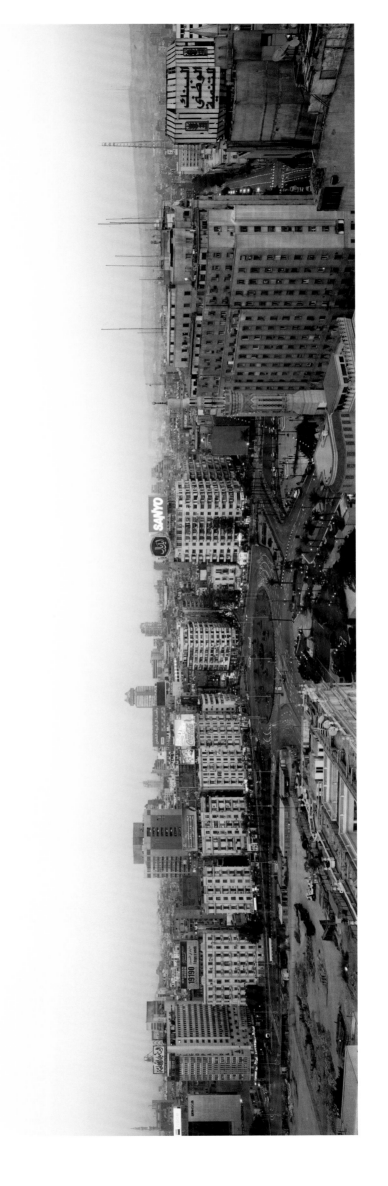

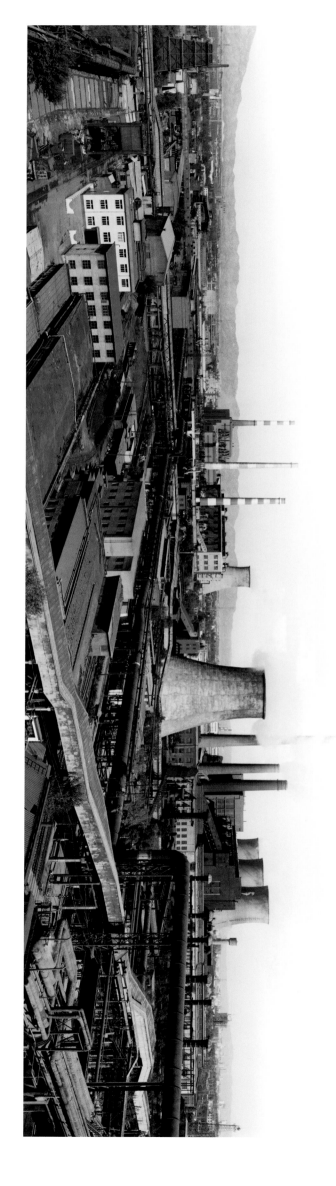

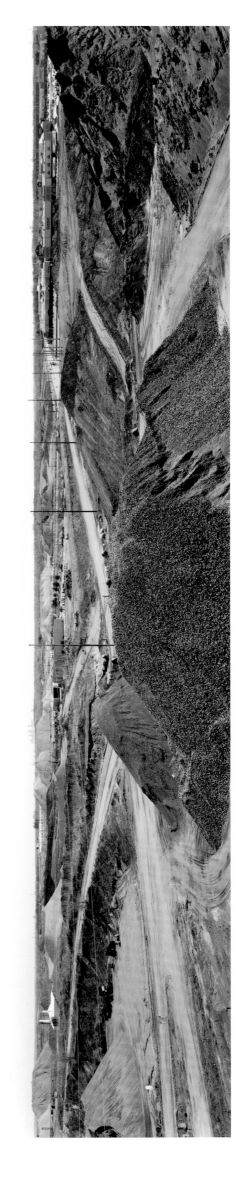

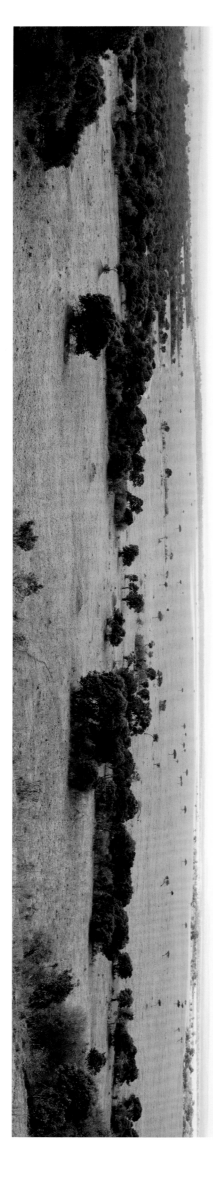

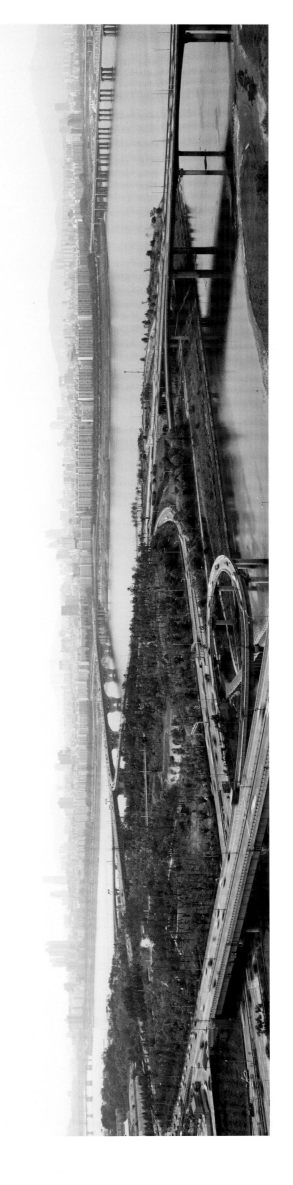

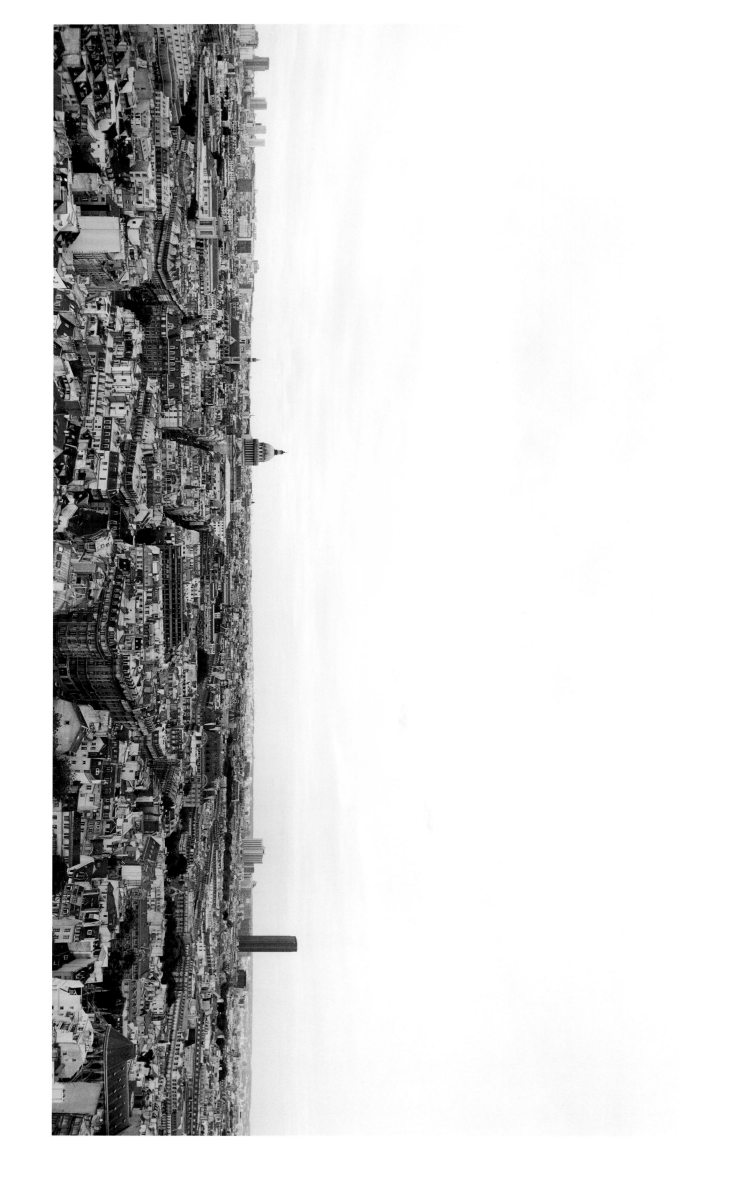

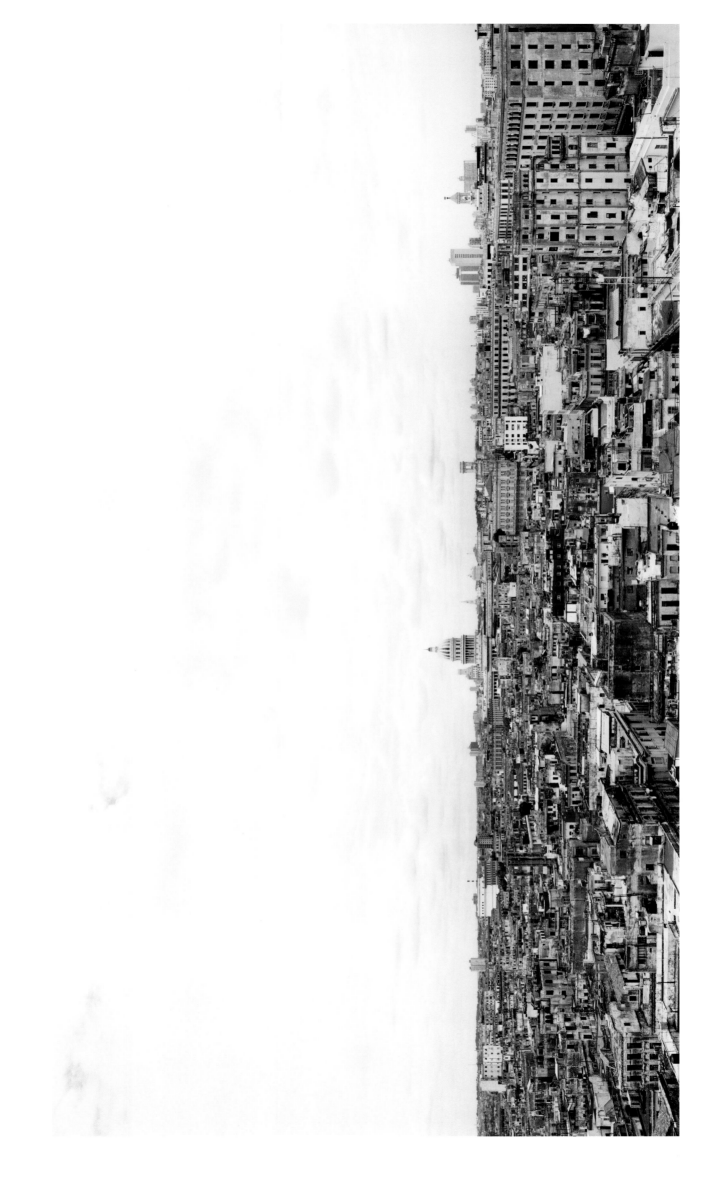

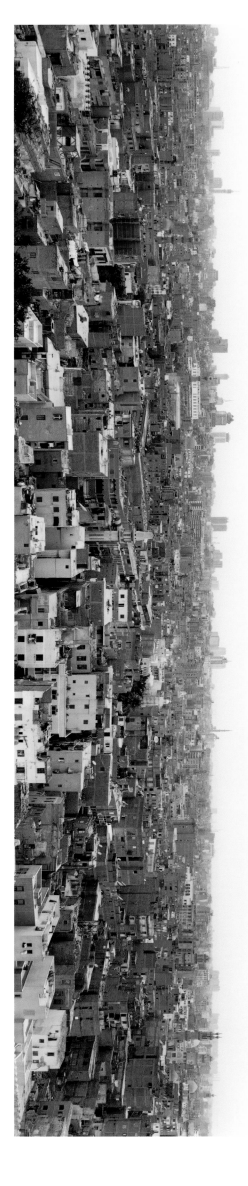

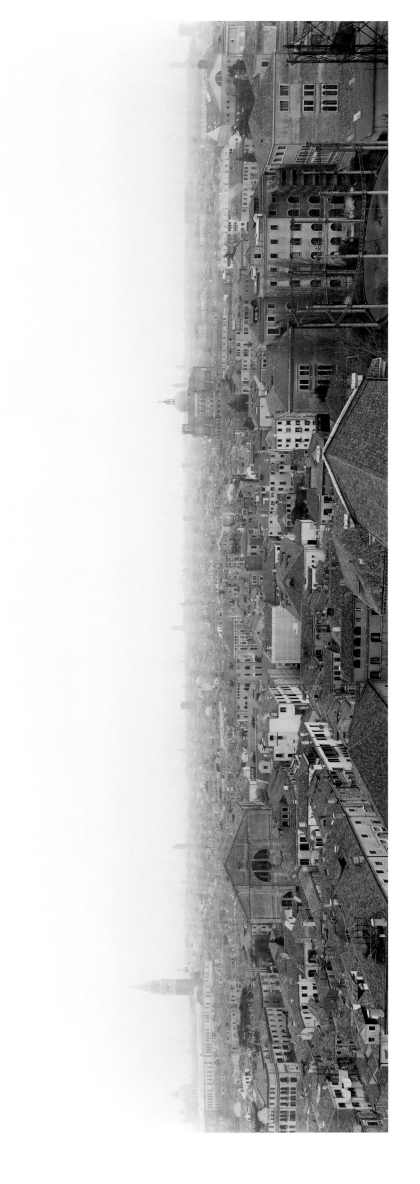

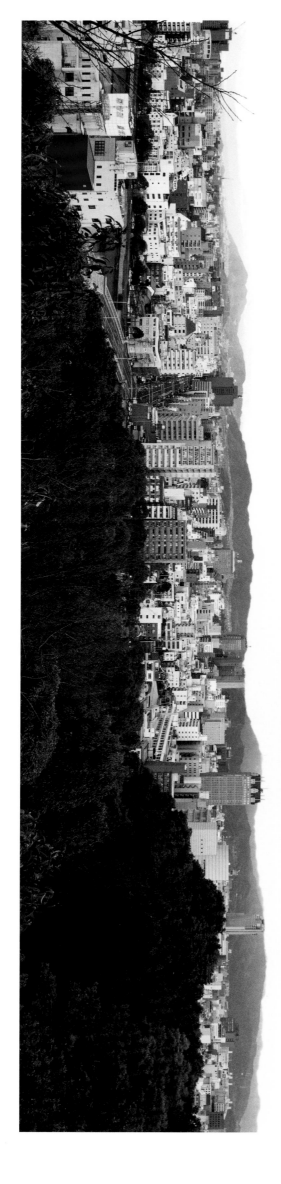

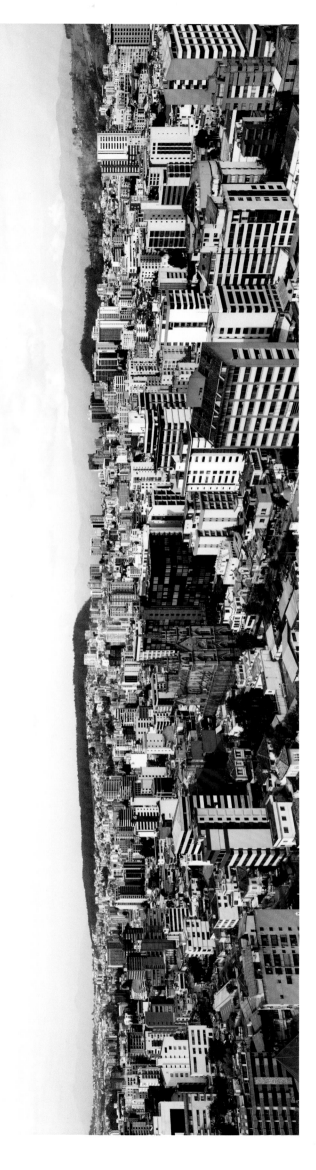

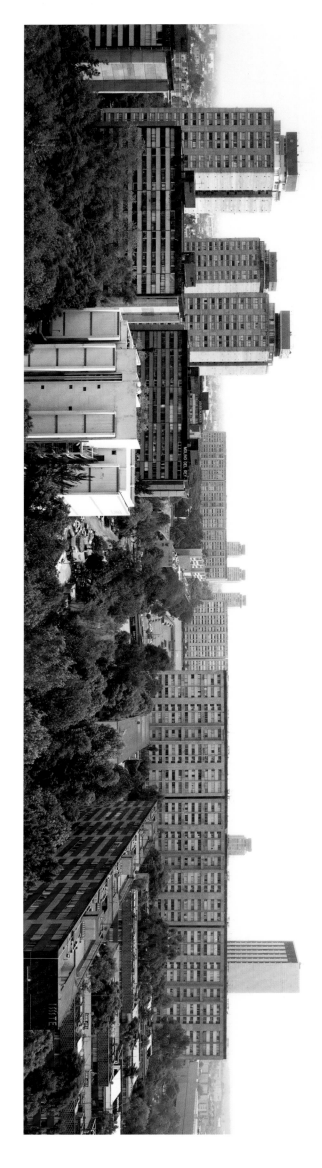

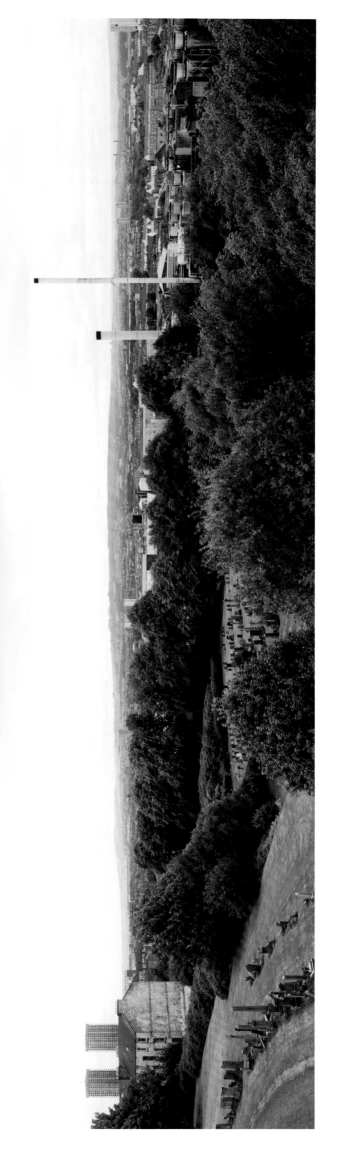

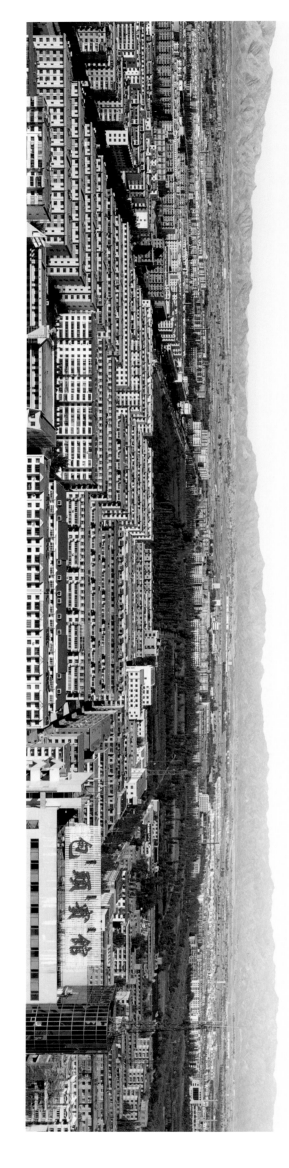

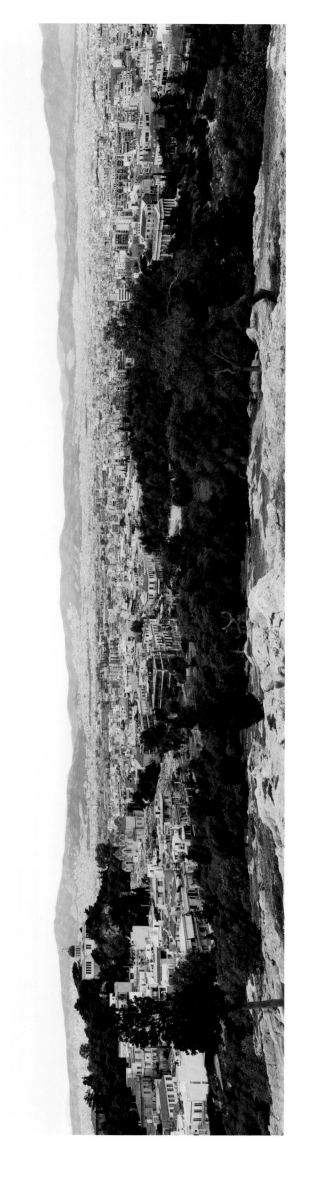

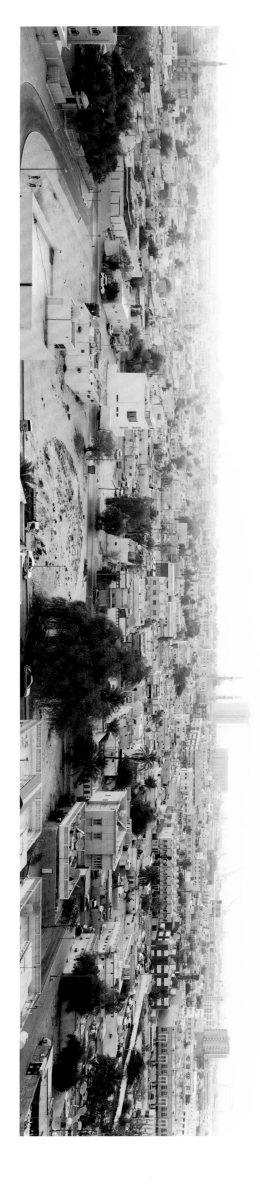

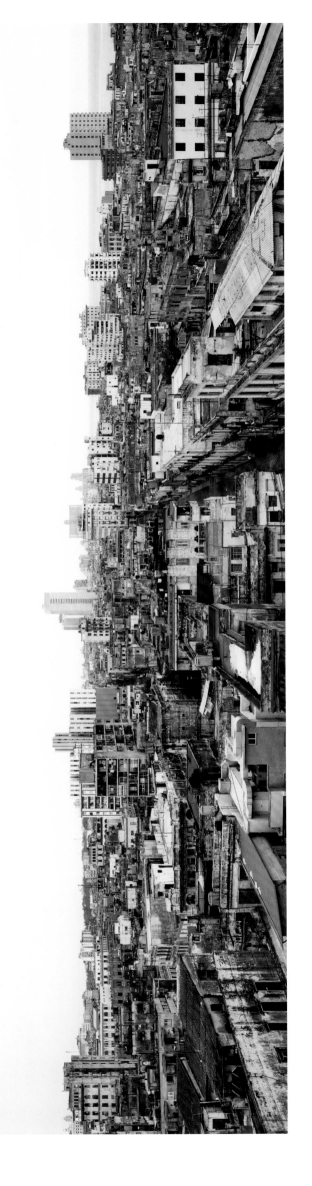

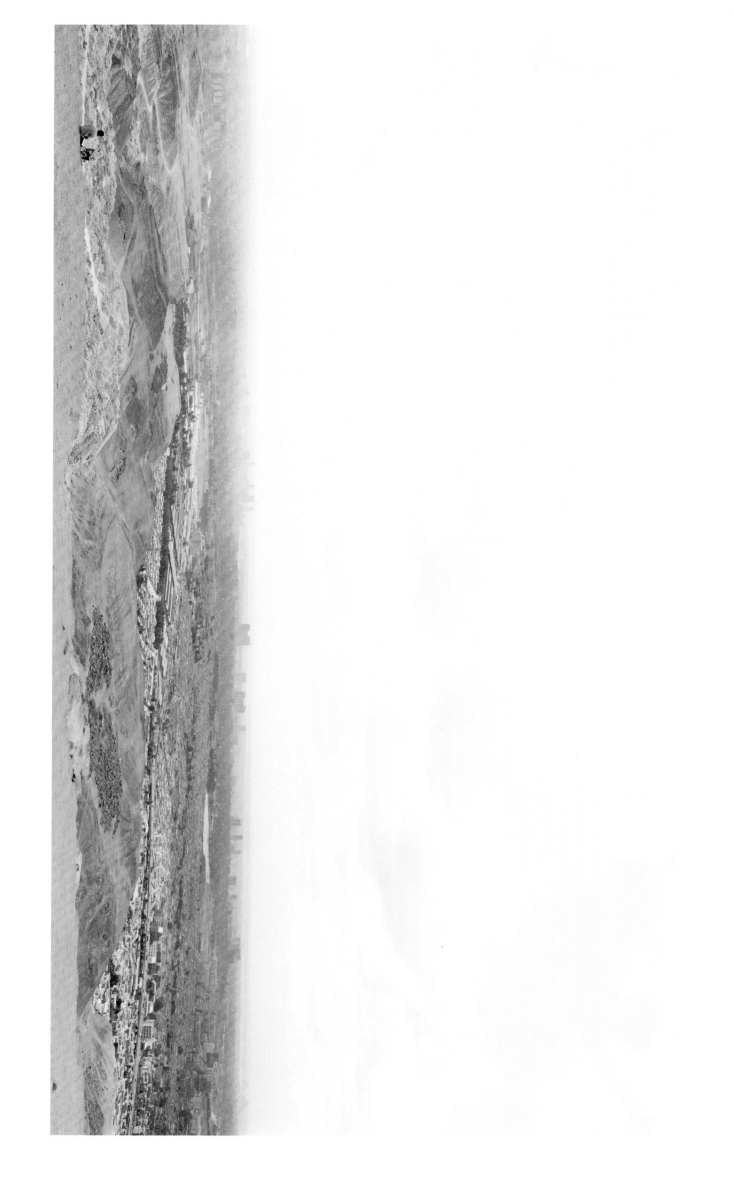

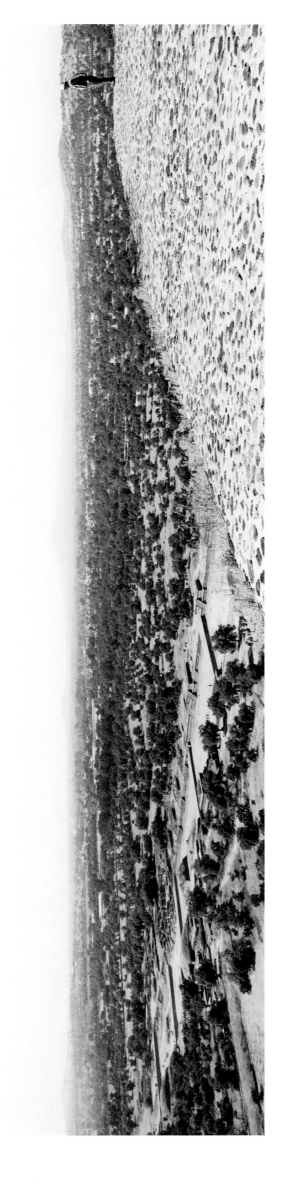

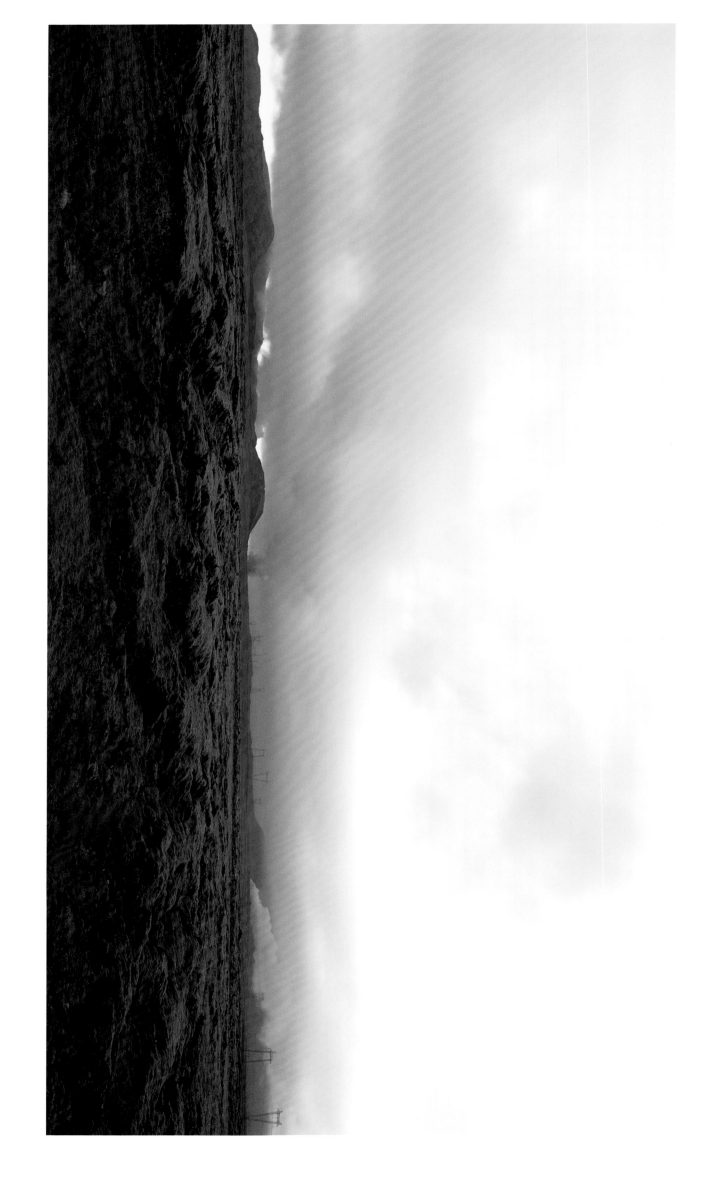

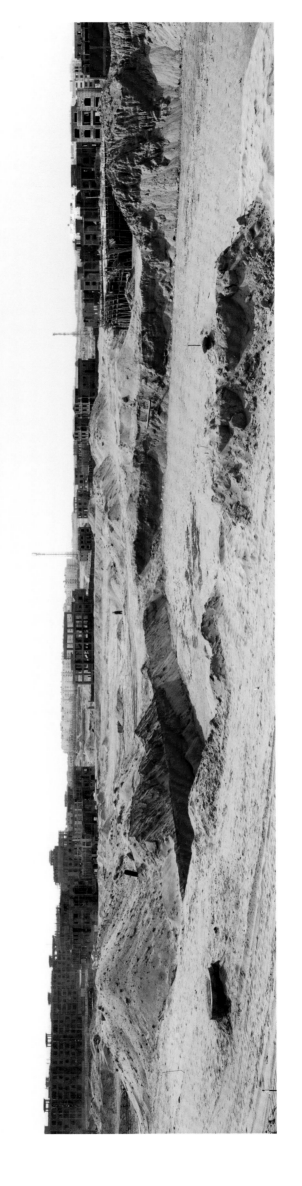

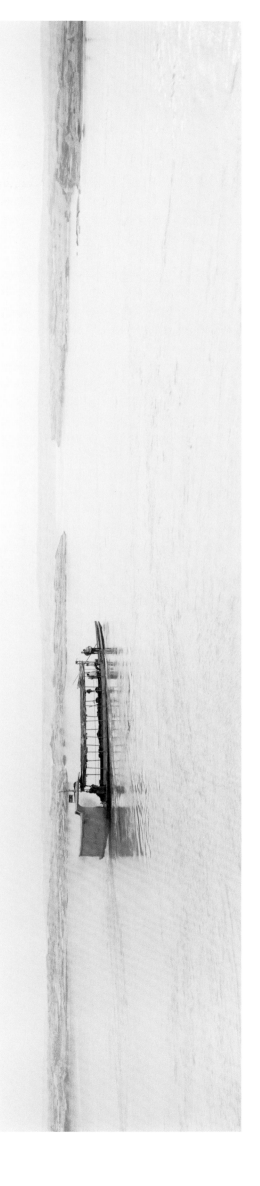

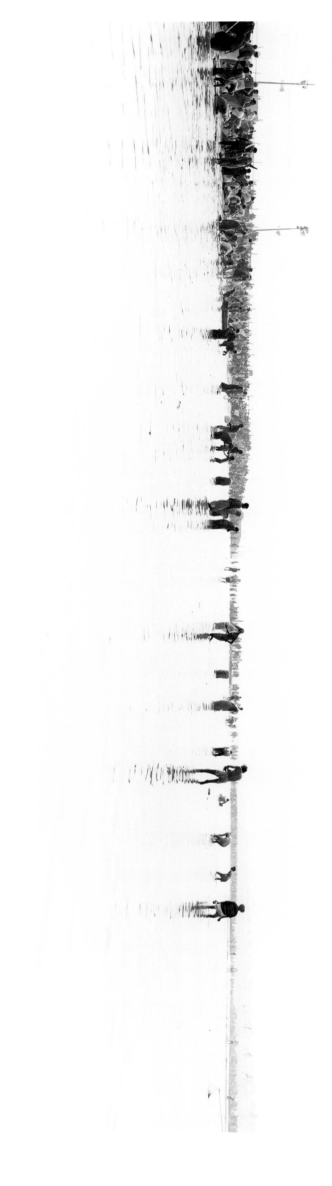

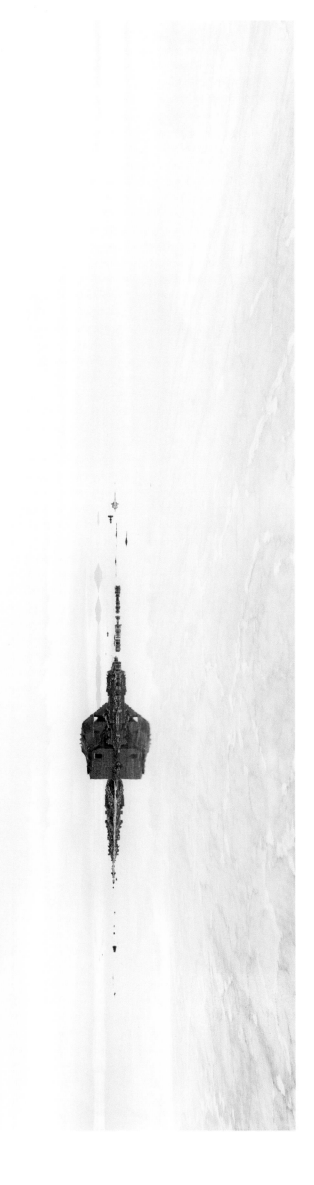

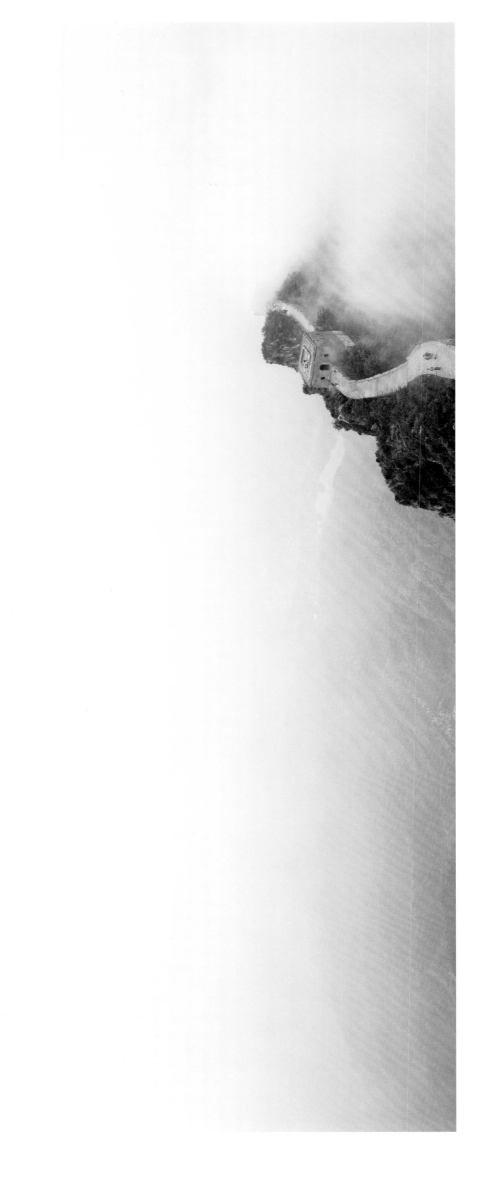

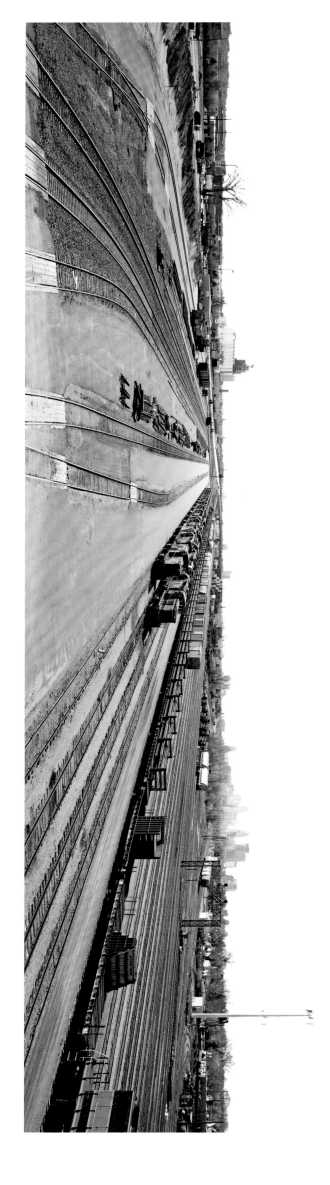

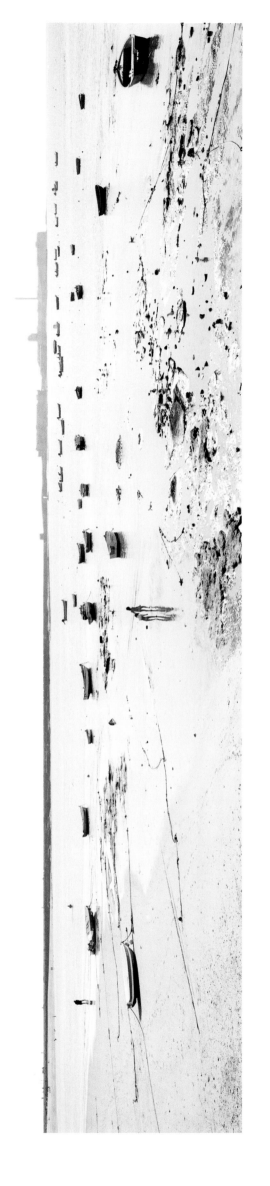

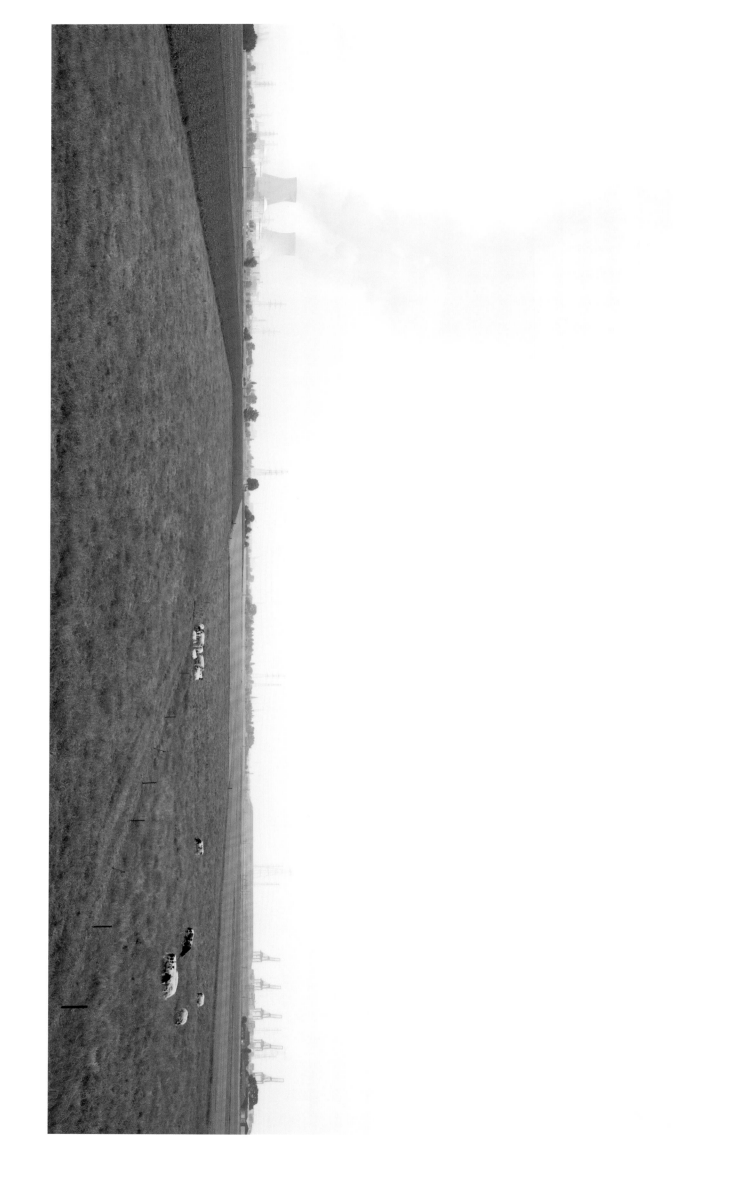

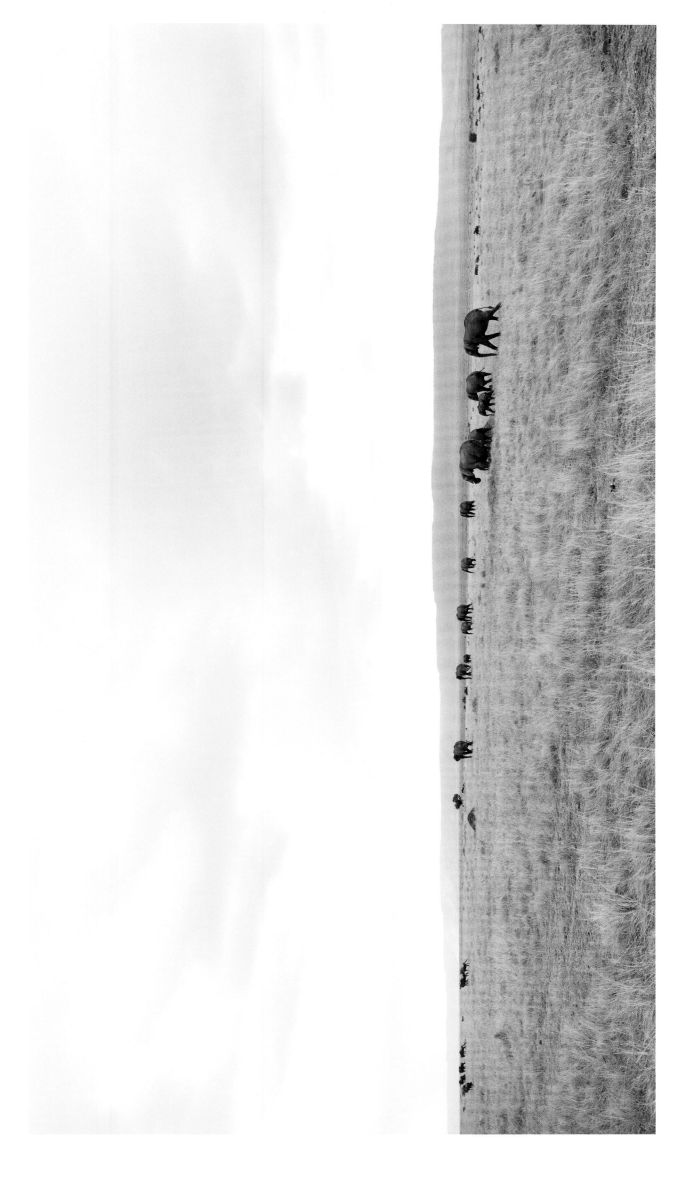

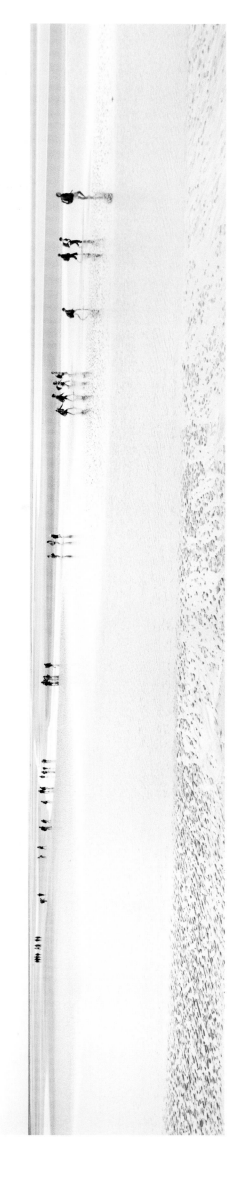

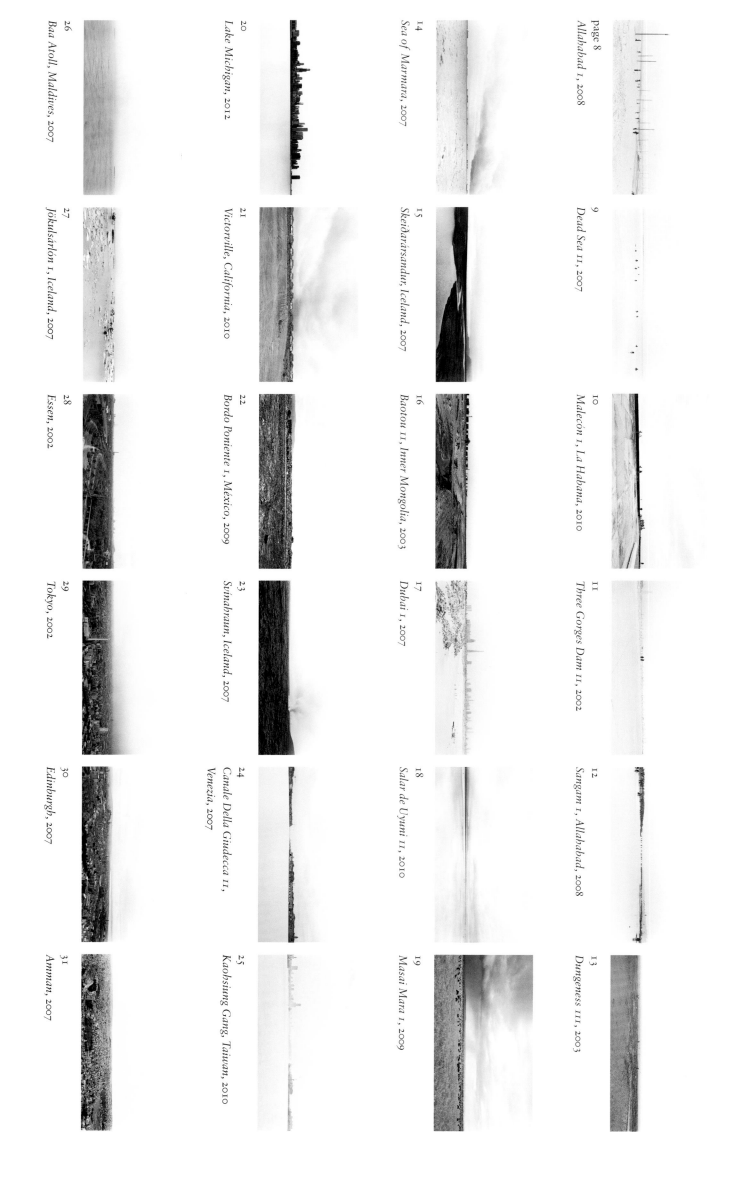

page 8
Allahabad 1, 2008

9
Dead Sea 11, 2007

10
Malecón 1, La Habana, 2010

11
Three Gorges Dam 11, 2002

12
Sangam 1, Allahabad, 2008

13
Dungeness 111, 2003

14
Sea of Marmara, 2007

15
Skeiðarársandur, Iceland, 2007

16
Baotou 11, Inner Mongolia, 2003

17
Dubai 1, 2007

18
Salar de Uyuni 11, 2010

19
Masai Mara 1, 2009

20
Lake Michigan, 2012

21
Victorville, California, 2010

22
Bordo Poniente 1, México, 2009

23
Svínahraun, Iceland, 2007

24
Canale Della Giudecca 11, Venezia, 2007

25
Kaohsiung Gang, Taiwan, 2010

26
Baa Atoll, Maldives, 2007

27
Jökulsárlón 1, Iceland, 2007

28
Essen, 2002

29
Tokyo, 2002

30
Edinburgh, 2007

31
Amman, 2007

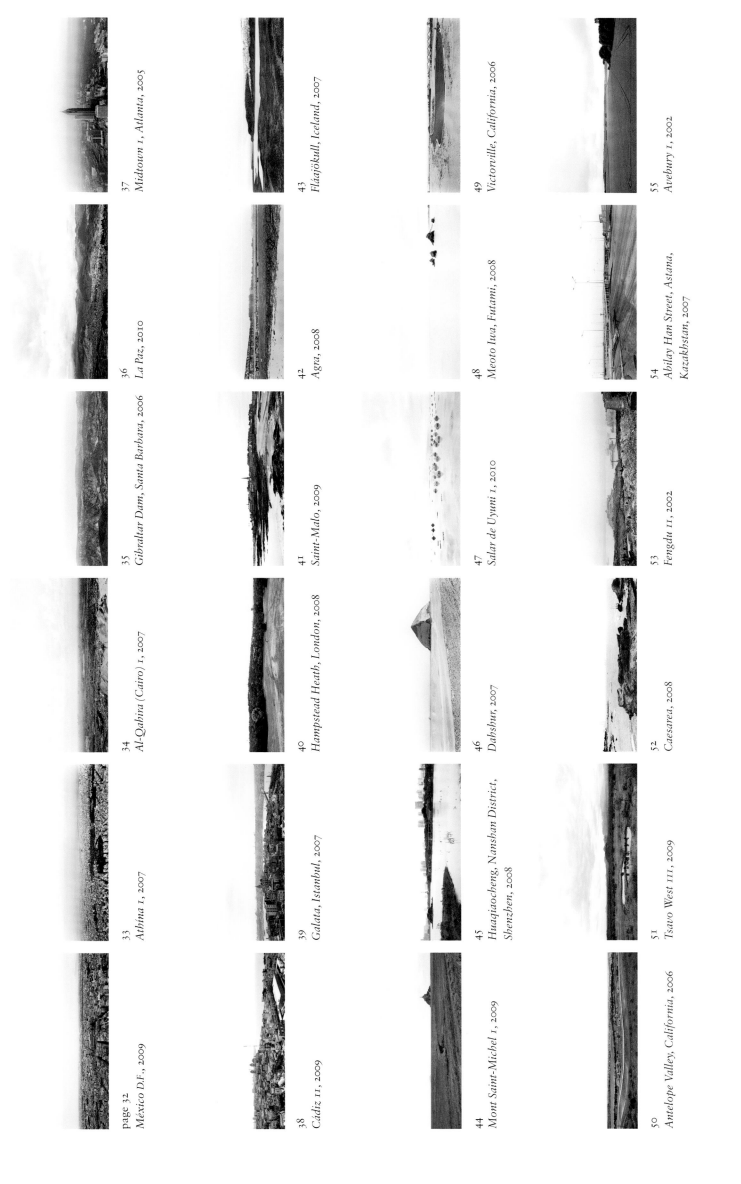

page 32
México D.F., 2009

33
Athina 1, 2007

34
Al-Qâhira (Cairo) 1, 2007

35
Gibraltar Dam, Santa Barbara, 2006

36
La Paz, 2010

37
Midtown 1, Atlanta, 2005

38
Cádiz 11, 2009

39
Galata, Istanbul, 2007

40
Hampstead Heath, London, 2008

41
Saint-Malo, 2009

42
Agra, 2008

43
Fláajökull, Iceland, 2007

44
Mont Saint-Michel 1, 2009

45
Huaqiaocheng, Nanshan District, Shenzhen, 2008

46
Dahshur, 2007

47
Salar de Uyuni 1, 2010

48
Meoto Iwa, Futami, 2008

49
Victorville, California, 2006

50
Antelope Valley, California, 2006

51
Tsavo West 111, 2009

52
Caesarea, 2008

53
Fengdu 11, 2002

54
Abilay Han Street, Astana, Kazakhstan, 2007

55
Avebury 1, 2002

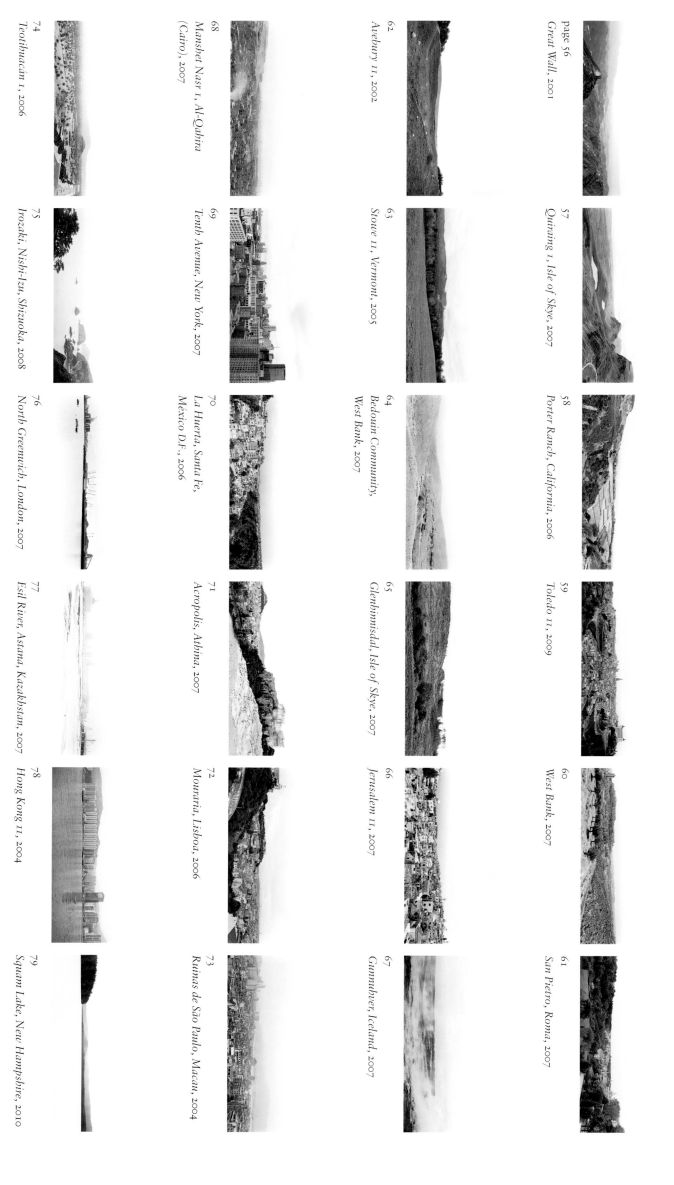

page 56
Great Wall, 2001

57
Quiraing 1, Isle of Skye, 2007

58
Porter Ranch, California, 2006

59
Toledo 11, 2009

60
West Bank, 2007

61
San Pietro, Roma, 2007

62
Avebury 11, 2002

63
Stowe 11, Vermont, 2005

64
Bedouin Community,
West Bank, 2007

65
Glenhinnisdal, Isle of Skye, 2007

66
Jerusalem 11, 2007

67
Gunnuhver, Iceland, 2007

68
Manshet Nasr 1, Al-Qahira
(Cairo), 2007

69
Tenth Avenue, New York, 2007

70
La Huerta, Santa Fe,
México D.F., 2006

71
Acropolis, Athina, 2007

72
Mouraria, Lisboa, 2006

73
Ruinas de São Paulo, Macau, 2004

74
Teotihuacán 1, 2006

75
Irozaki, Nishi-Izu, Shizuoka, 2008

76
North Greenwich, London, 2007

77
Esil River, Astana, Kazakhstan, 2007

78
Hong Kong 11, 2004

79
Squam Lake, New Hampshire, 2010

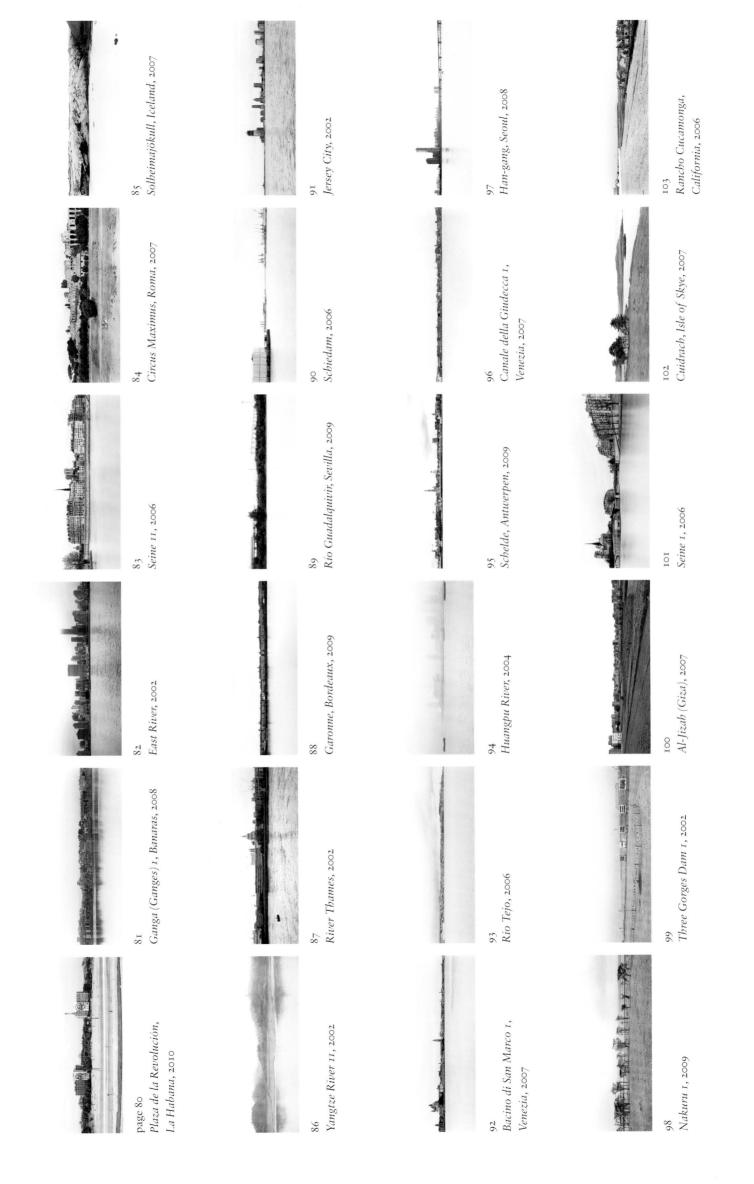

85
Solheimajökull, Iceland, 2007

91
Jersey City, 2002

97
Han-gang, Seoul, 2008

103
Rancho Cucamonga,
California, 2006

84
Circus Maximus, Roma, 2007

90
Schiedam, 2006

96
Canale della Giudecca 1,
Venezia, 2007

102
Cuidrach, Isle of Skye, 2007

83
Seine 11, 2006

89
Río Guadalquivir, Sevilla, 2009

95
Schelde, Antwerpen, 2009

101
Seine 1, 2006

82
East River, 2002

88
Garonne, Bordeaux, 2009

94
Huangpu River, 2004

100
Al-Jizah (Giza), 2007

81
Ganga (Ganges) 1, Banaras, 2008

87
River Thames, 2002

93
Rio Tejo, 2006

99
Three Gorges Dam 1, 2002

page 80
Plaza de la Revolución,
La Habana, 2010

86
Yangtze River 11, 2002

92
Bacino di San Marco 1,
Venezia, 2007

98
Nakuru 1, 2009

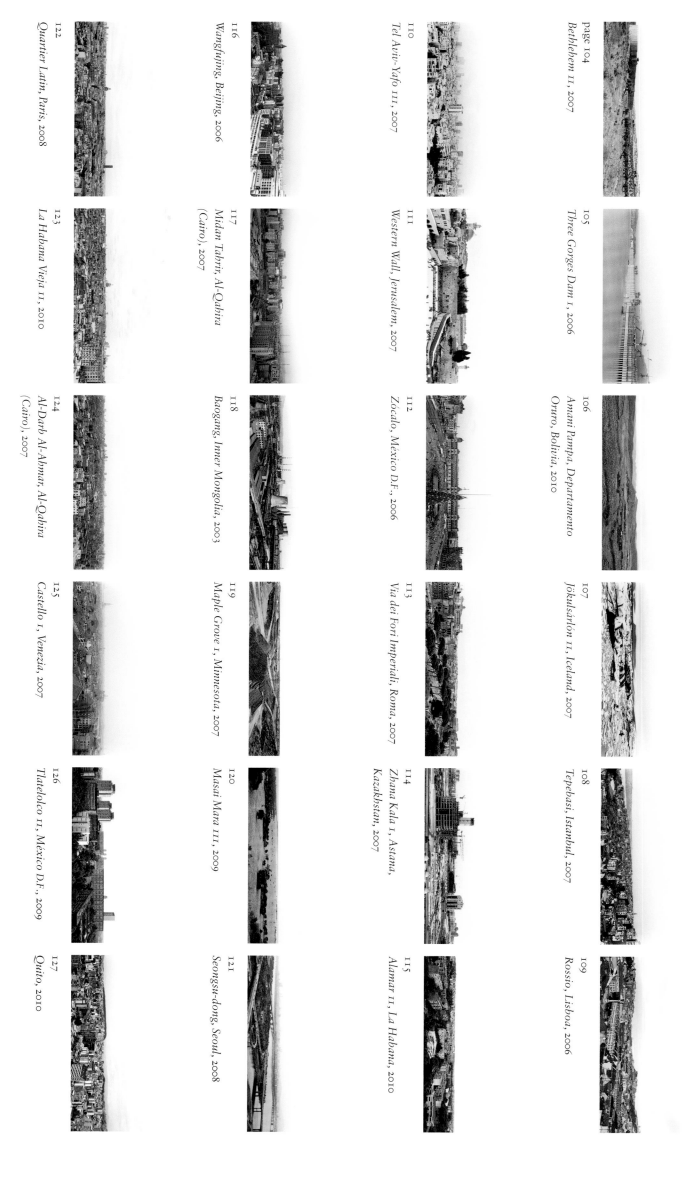

page 104
Bethlehem 11, 2007

105
Three Gorges Dam 1, 2006

106
Amani Pampa, Departamento
Oruro, Bolivia, 2010

107
Jökulsarlón 11, Iceland, 2007

108
Tepebasi, Istanbul, 2007

109
Rossio, Lisboa, 2006

110
Tel Aviv-Yafo 111, 2007

111
Western Wall, Jerusalem, 2007

112
Zocalo, México D.F., 2006

113
Via dei Fori Imperiali, Roma, 2007

114
Zhana Kala 1, Astana,
Kazakhstan, 2007

115
Alamar 11, La Habana, 2010

116
Wangfujing, Beijing, 2006

117
Midan Tahrir, Al-Qahira
(Cairo), 2007

118
Baogang, Inner Mongolia, 2003

119
Maple Grove 1, Minnesota, 2007

120
Masai Mara 111, 2009

121
Seongsu-dong, Seoul, 2008

122
Quartier Latin, Paris, 2008

123
La Habana Vieja 11, 2010

124
Al-Darb Al-Ahmar, Al-Qahira
(Cairo), 2007

125
Castello 1, Venezia, 2007

126
Tlatelolco 11, México D.F., 2009

127
Quito, 2010

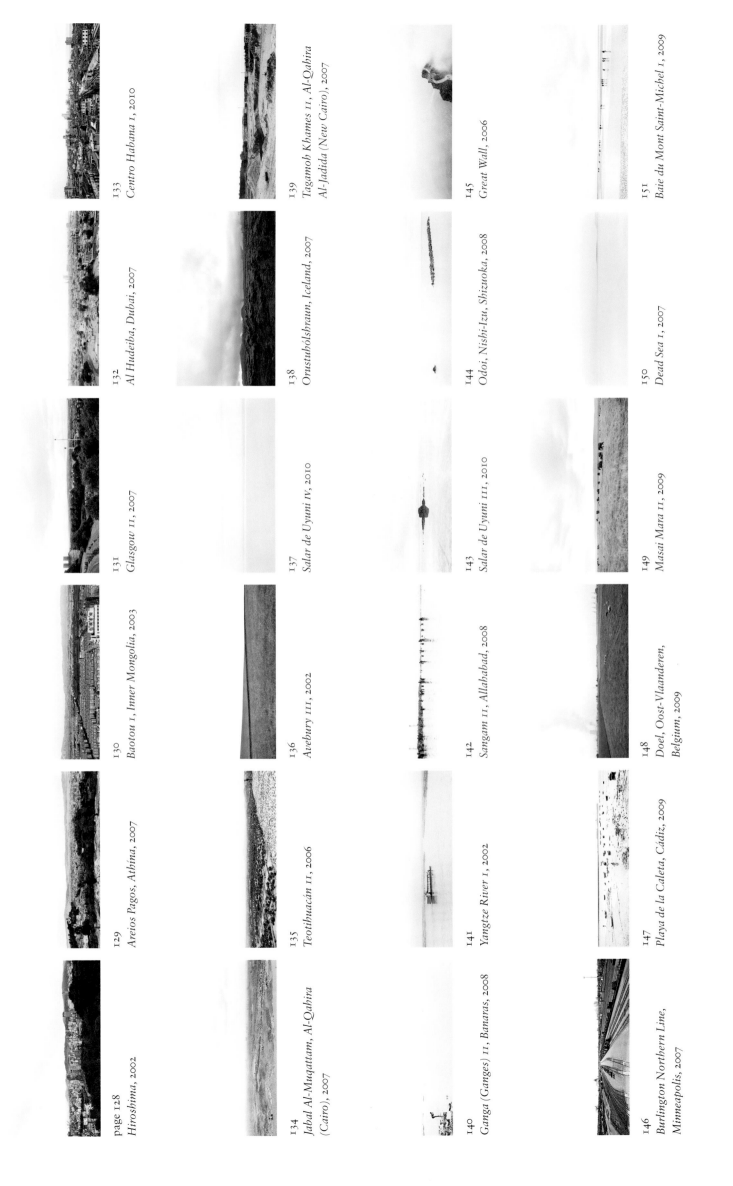

page 128
Hiroshima, 2002

129
Areios Pagos, Athína, 2007

130
Baotou 1, Inner Mongolia, 2003

131
Glasgow 11, 2007

132
Al Hudeiba, Dubai, 2007

133
Centro Habana 1, 2010

134
Jabal Al-Muqattam, Al-Qahira
(Cairo), 2007

135
Teotihuacán 11, 2006

136
Avebury 111, 2002

137
Salar de Uyuni IV, 2010

138
Orustubólsbraun, Iceland, 2007

139
Tagamob Khames 11, Al-Qahira
Al-Jadida (New Cairo), 2007

140
Ganga (Ganges) 11, Banaras, 2008

141
Yangtze River 1, 2002

142
Sangam 11, Allahabad, 2008

143
Salar de Uyuni 111, 2010

144
Odoi, Nishi-Izu, Shizuoka, 2008

145
Great Wall, 2006

146
Burlington Northern Line,
Minneapolis, 2007

147
Playa de la Caleta, Cádiz, 2009

148
Doel, Oost-Vlaanderen,
Belgium, 2009

149
Masai Mara 11, 2009

150
Dead Sea 1, 2007

151
Baie du Mont Saint-Michel 1, 2009

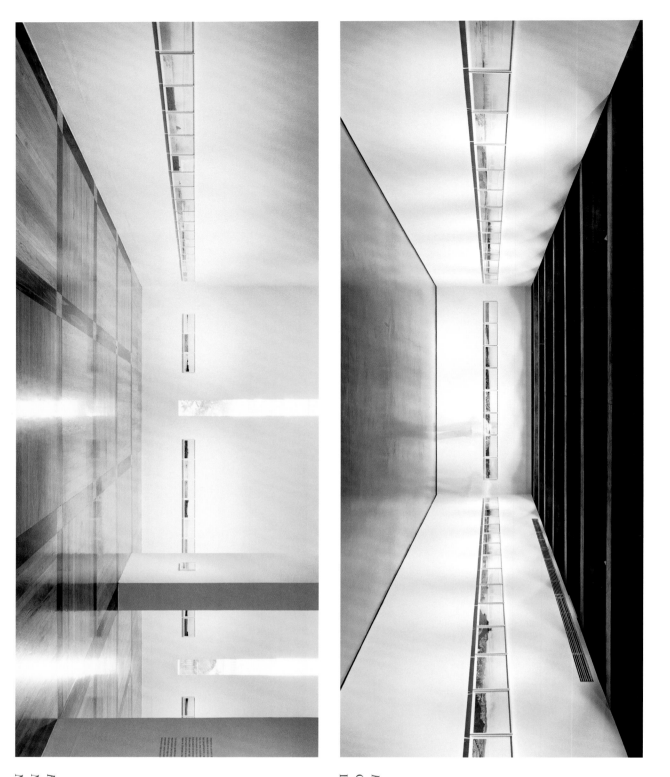

160

Horizons installation at the
Museo de Arte Contemporáneo,
Monterrey, Mexico, 2010.

Horizons installation at the
Calouste Gulbenkian Foundation,
Lisbon, 2007.

Uncertain Distances
SZE TSUNG LEONG

A HORIZON, in its simplest manifestation, is a line separating ground from sky. This gesture forms the basis by which the earth's surface is comprehended from an individual's point of view. When drawn on a two-dimensional surface, it has been understood, since the development of linear perspective six centuries or so ago, to create the reference plane upon which we can see the illusion of three-dimensional objects sitting in relationship to each other in a unified space. On a perceptual level, the horizon represents the farthest we can see. On a cognitive level, the horizon marks the limit of what we know, a line that weaves vision and knowledge together. It is, according to Webster's, "the fullest range or widest limit of perception, interest, appreciation, knowledge, or experience."

Understood with this expanded capacity, the horizon forms a boundary separating the seen from the unseen, the known from the unknown, the inside from the outside, the familiar from the foreign. Any boundary automatically creates, through the act of division, a relationship between what is included inside and what is left outside, making the outside just as important as the inside in knowing and understanding the inside itself. Intelligibility is just as much a question of establishing "this is not" as it is of determining "this is." National borders are just as much about defining an idea of what "we are not" as they are about deciding what "we are." A horizon is just as much about what we cannot see beyond it as it is about what we can see before it. In other words, the horizon always points to what is outside.

It is this relationship to the outside that gives the horizon an additional implication: that it establishes a sense of imminence, or of something just becoming apparent, as suggested by the phrase "on the horizon." What is not yet seen or not yet known always surrounds and encroaches into the visible or known, and permeates thinking about and looking at our extended surroundings. The challenge that the unknown presents can escalate the fear to solidify or reinforce borders, to build walls. But the interest and curiosity that the unknown also elicits can drive the wish to draw new maps, to roam unseen territories, to observe the seemingly empty regions of space. This drive is an impulse to approach the unknown, that is, to drift toward the horizon.

To drift toward the horizon implies approaching the outside, the unseen, the unknown, the foreign. Yet if the horizon is always the farthest visible point, the widest limit of knowledge, then any approach to the horizon will be accompanied and preceded by the range of familiarity that delineates the horizon in the first place. The familiar, to some degree or another, is always immanent in the foreign, acting as a form

of navigation, a compass by which the outside can become understandable and legible.

This relationship between familiar and foreign guides the act of looking at anything just over the horizon of recognition. When faced with unknowns, thinking and seeing begin with associations and resemblances: "this reminds me of ...," or "this looks like" The distinctions between known and unknown overlap in efforts to establish markers for navigation, and thus the range of the known indicated by the horizon can drift. As a result, the distances separating iconic from quotidian, extraordinary from mundane, picturesque from unsettling, are never constant. Rather than by solid lines and divisions, they are characterized more by uncertain distances, smooth gradations, and overlapping fields.

The drifting horizon reveals the tendency for the arbitrariness of distinctions, the randomness of orders. Political borders, for example, rarely define essences—they are only the boundaries that overlap in the most dominant way, over complex, ever changing, often amorphous layers of regions and forces, whether geological, historical, economic, social, or conceptual. These dense layers are composed more by movements and fluctuations—continental drift, invasions and conquests, trade and distribution, migrations and dispersals, exchanges and influences—than through segregation and ossification into discrete entities. Any way we divide up the world (Spanish, Indian, Mexican,...), overlaps with other orders (Hispanic, Aryan, American,...), and in turn overlaps with others (colonial, native, mestizo,...), and inevitably will obscure other, perhaps more interesting and unnamed,

orders. As a result, the boundaries of what we consider the local need not be limited to physically confined, specific places. The local can be mobile and dispersed.

The images that comprise this series could be of places familiar or foreign, of sites encountered or unknown, of locations recognized or uncertain. They could be readily named, or perhaps not identifiable at all. They could be encountered on an everyday basis, a short distance away, or on the other side of the globe. They could be taken for one place but actually be another. They could make the unknown comprehensible, or the known unfamiliar—what is just over the horizon does not necessarily have to be physically distant. They could be of places unheard of or perhaps just out of the reach of recognition. Could it be Mexico City? Lisbon? Delhi? Macau? In looking, we begin a process of traveling in order to place ourselves. The images could make one think, "this place looks like ...," or "this place reminds me of ...," or "isn't this ...?" Perhaps where these images are exactly is not so relevant. Their adjacencies could form relationships and connections that transcend existing borders, proximities, distances.

These images were not made as documents holding any set truths. They are meant only as suggestions. They are not necessarily images of moments, events, or objects. They are incomplete fragments of the globe. Their order can be rearranged, open to new and unforeseen interpretations. They are emptied, to whatever degree is possible or impossible, of specific meanings, sometimes as physically empty as possible. They are attempts to depict space on the surface of the photograph, spaces into which viewers can project their own horizons.

Three Perspectives
DUNCAN FORBES

IN A GENEROUS GESTURE Sze Tsung Leong invites us each to project our own horizons, to locate ourselves—imaginatively, cognitively—in relation to his series through our own archival ordering. This immediately makes what is an engaging procedure sound far too dry—it proves to be less a task of classification than one of playful comparison and sequencing. *Horizons* is a work of inventive re-territorialization and turning through the pages of this book inspires further acts of emplacement. The permutations for this re-making of place are endless, playing between a range of formal, cultural, and affective registers. Landscapes of obvious contrast and continuity soon give way to a more subtle stratagem of similarity and difference. Formal features—the protrusion of Mont Saint-Michel, for example—echo across disparate territories, shaking up stale cultural associations and aesthetic categories.[1] Cityscapes of the Latin Quarter in Paris and Old Havana appear suddenly, mesmerically, to inhabit each other.[2] And another short series, selected for exhibition, allowed a quixotic reconfiguration of my own sense of place: Iceland, Amman, Edinburgh, Seoul, and the Quiraing of Skye.[3]

Such conscious aesthetic reordering creates, in many ways, a world apart. *Horizons* is perhaps best viewed at exhibition where the global scope and logic of its structural composition are most fully brought out. But there is also an open-ended quality about *Horizons* that at once defers to, and distances itself from, the typological grandeur in which a certain strand of art photography is so heavily invested. In my own mind's eye I favor randomness, a spatial parlor game of infinite surprise and extension. At a distance the rhythm of a flowing, axial line emerges. It unifies component parts and transforms the series yet again by augmenting its paradoxical qualities of the local and the global, of stillness and movement, of abstraction and embodiment.

In his elegant descriptive statement accompanying the series Leong clearly privileges this structural motility, exploiting the systematic, aggregate quality of photography to enable an endless play of difference. *Horizons* explores the modernist principles that meaning is relational and that the important thing in a work of art is not so much what it represents but what it transforms. In formal terms this transformation is achieved by means that are eminently photographic: a large- or medium-format analogue camera that enables a maximum of detail; wide-angled lenses to create a broader, non-human field of vision; a uniformly level horizon line, often from an elevated viewpoint; even lighting conditions; and consistency in printing and presentation. These techniques have a history deeply embedded in the evolution of modernist meanings. Landscape elements are abstracted and systematized to induce a response that is carefully determined, but also directed toward an opening up of experience. The formal qualities of *Horizons*—the tensions it generates between, say, rhythm and stasis, the particular and the general—are what direct its progress toward the anti-real.

Above all, *Horizons* is productive of the metaphor of perspective, what Carlo Ginzburg neatly defines for us as "a model of cognition based on a plurality of points of view."[4] Historically, as Ginzburg argues, the notion of perspective is surprisingly oblique, enabling both subjective as well as more analytical, and thus potentially verifiable, truths. He identifies three

1. See pages 44–49.
2. See pages 122–23.
3. See pages 107, 31, 30, 121, and 57.
4. Carlo Ginzburg, "Distance and Perspective: Two Metaphors," in *Wooden Eyes: Nine Reflections on Distance*, trans. Martin Ryle and Kate Soper (New York, 2001), pp. 152–53.

broad perspectival signs in modern form: those of conflict (Machiavelli, Marx), multiplicity (Leibniz, Nietzsche) and a kind of secular accommodation (Hegel). Depending on its morphology, *Horizons* might potentially subsume any of these tendencies. It seems to me, however, that Leong's version veers more toward an ethic of multiplicity, a quiet cosmopolitan take on the seemingly unlimited interpretative play associated with the modernist imagination. Bound by the formal strategies of distance and continuity, his "incomplete fragments of the globe" map out a territory of harmonious difference. Moreover, despite their profusion and variegation they are rarely disorienting. There is no confusion of hyperspace here.

This ethic is itself a specific viewpoint and I want to embellish it in three different ways. First, *Horizons* evidently presents a globalized perspective, although one that seems subtly to undermine the significance previously accorded by photography to place. It is strikingly different, for example, from the context of modernization embodied by the industrial and largely national typologies of Bernd and Hilla Becher, which now appear to be of another age.[5] Indeed, it is tempting to interpret Leong's series as expressive of a distinctively new form of global present, one in which—unified by a horizon line—modernity has become spatially one. As Peter Osborne has argued, in the wake of the breakdown of so-called Cold War binaries we live in a world comprised of many modernities, each "socio-spatially specific forms of experience of (the one) global modernity (socio-spatially embedded perspectives on its globality, if you like)."[6] "Perspectives on globality" would form a fine, prosaic subtitle for *Horizons*, a spatial dialectic of global places and flows bound by the universal reality of capital, the now inescapable horizon of all social life. From today's standpoint it is possible to turn back and consider an intriguing spatial dynamic in the history of photographic typology. In comparison with his twentieth-century predecessors, Leong's serial imagery appears to draw on a very different apprehension of social form.

What might this new articulation of space mean for our understanding of *Horizons* as landscape? In an essay published in 1984, the geographer J. B. Jackson argued that horizontality was a predominant feature of the perception of the American landscape, a response to "increased mobility, and even more, an increased experience of uninterrupted speed."[7] But might we not read this today as a rather archaic formulation, at once the description of a now generalized condition (vertical Europe, too, has its surfeit of commercial strips and low-slung shopping malls), as well as an experience of landscape that seems oddly sedentary in an era of digital dis- and relocation? If there has been a recent spurt of interest in the formal properties of the horizon line in photography (Hiroshi Sugimoto is only the most prominent example here), this may have less to do with the demarcation of specific *topographies* than the unconscious articulation of the creative potential of *topology*, the intricate, connective dimensions of the relations of place as they are constantly rewoven in contemporary space and time. As any number of geographers have suggested, today's flows of culture, capital, and goods weaken the bounded territory of the nation state in favor of the enhanced interlinkage of global cities. Perhaps we are witnessing an emerging technological unconscious, a response to increasingly formative networks of global positioning and interrelation, what Nigel Thrift has recently described as proliferating modes of "hypercoordinated address"?[8] *Horizons*, it seems to me, pursues something of this connectivist ontology of place even as it affirms a more traditionally empirical, perspectival rendition of the earth's surface.

My second embellishment concerns the projective dimension of *Horizons*, in spatial terms certainly, but also in the context of time. Here the series' relation to *History Images* is decisive, Leong's earlier, electrifying book about the physical and political erasure of history in China's urban environment.[9] *History Images* is more than a superficial documentary record: it forms an archaeology of the destruction of the past. Its pages reveal

5. See Blake Stimson, *The Pivot of the World: Photography and Its Nation* (Cambridge, Mass., 2006) for an enlightening discussion of the Bechers' work.

6. Peter Osborne, "Non-Places and the Spaces of Art," *Journal of Architecture* 6, no. 2 (2001), p. 185.

7. J. B. Jackson, "Agrophilia, or the Love of Horizontal Spaces," quoted in John Wylie, *Landscape* (Milton Park, England, and New York, 2007), p. 50.

8. Nigel Thrift, "Remembering the Technological Unconscious by Foregrounding Knowledges of Position," *Environment and Planning D: Society and Space* 22 (2004), p. 178.

9. Sze Tsung Leong, *History Images* (Göttingen, 2006).

is not reducible to any particular position in this debate, but it does engage us in thinking about the character of cosmopolitan values: the practices of cultural pluralism, the act of crossing boundaries, the significance to culture of transitional space, the ongoing transformation of relations between the local and the global, the pursuit of critical knowledge through dialogue. Like the notion of perspective, as Ginzburg frames it, *Horizons* constitutes "a space to meet," an implicit challenge to what has been described as the "banal globalism" of the West's media, marketing, and tourist industries. The force of *Horizons'* utopian charge is the possibility of forging newly egalitarian modes of spatial practice.

However, I am also struck—particularly with Leong's *History Images* in mind—by the acute instability of cosmopolitan values and the spatial chaos in which we, as global citizens, now struggle to survive. We are facing, as Henri Lefebvre once put it, a "trial by space": "[S]pace's investment—the production of space—has nothing incidental about it: it is a matter of life and death."[10] If my final embellishment is to invoke *Horizons'* cosmopolitan echoes, then I wish also to emphasize the conflictual environment in which they sound out. The globalization of space under capitalism is also about the suppression of difference. The vast, totalizing drive of urbanization in particular generates interchangeable spatial units in which each horizon looks increasingly the same. At the same time, urban interdependence also breeds fragmentation as places become dislocated and disconnected within ever more uneven spatial hierarchies. In our age of anxiety, the relations of space and place, too, become increasingly fraught.

Today, cosmopolitanism, as one of its supporters puts it, is in "grave jeopardy."[11] It is in this context that Leong's series works as a cipher of hope, a reminder of the multidimensional character of spatial politics. *Horizons* promises us something as yet unseen. It helps us imagine the multiple terrain on and through which the democratization of global space needs to be fought.

neighborhoods, formed organically over centuries or decades, reduced to little more than builders' rubble. Older, low-rise habitation is replaced—crushed might be a better term—by the speeded-up vertical infrastructure of China's exploding cities. In this forensic imagery of urban layering, captured in the midst of the country's helter-skelter transition to capitalism, time acquires a quality and a presence that seems to propel history forward. History no longer speaks retrospectively, but in the present tense.

Horizons, it seems to me, is in part an elaboration of this projective reach. Conceptually, and even formally, it is already embedded in *History Images* as the utopian dimension that a flattened present seeks to absorb. It is the future about which contemporary China, with its now fixed horizon of history, has no means to think. *Horizons'* utopian force is the opening up of this brute closure, a renewed attention to the flow of possibilities seemingly denied by the totalizing dynamic of our global present. It probes beyond the shallow temporality in which we all are trapped. The series is a reminder that history remains radically open, that despite the pronouncements of recent liberal ideology there is no "end" in sight. Transfigured aesthetically and freed from the mundane, each vista demarcates a space of yearning.

Horizons, then, can be read as an imaginative refiguring of something already latent in our present and a utopian projection of what the world might become. It is less a representation of the world than it is an attitude toward it, an ethos, if you like, premised on the necessity of global thinking. Here the notion of cosmopolitanism comes to mind, a critical position, albeit highly contested, that offers strategic resources for the formulation of a properly democratic global citizenship.

For its various proponents, cosmopolitanism is symptomatic of an epochal shift in the nature of modernity, a response to the often violent re-territorialization of global social space since the early seventies. It articulates above all the problem of how to negotiate the tensions between universal values and the realities of spatial and cultural difference. *Horizons*

10. Henri Lefebvre, *The Production of Space*, trans. Donald-Nicholson Smith (Oxford, 1991), p. 417.

11. Martha C. Nussbaum, "Kant and Cosmopolitanism," in *The Cosmopolitanism Reader*, ed. Garrett Wallace Brown and David Held (Cambridge, England, and Malden, Mass., 2010), p. 42.

The Infinite View

CHARLOTTE COTTON

A FEW YEARS AGO I approached Sze Tsung Leong to write an essay about repetition in photography.[1] My motivation for asking him was in part a genuine if naïve desire to hear directly from one of photography's new talents about why the device of repetition (and especially in the genre of landscape photography) was so prominent in this era of photography as contemporary art. It was also coupled with my belief that he would have in his writing, just as in his pictures, something specific to say about this perhaps overworked and potentially formulaic motif within contemporary photographic practice. His subsequent essay is convincing both in the way it reminds us of why the search for the same picture in different places is an enduringly rich photographic terrain, but also in the way it reveals the concepts and ambitions that underpin his *Horizons* project. *Horizons* is an incredibly ambitious project, not simply in its practicalities of the research in finding these pictures-waiting-to-happen in a multitude of countries and sites, nor in operating large-format camera equipment to capture the horizons of land-, water-, and city-scapes. The ambition of *Horizons* is to create a sense of the infinite range of diversities and synergies in the actual world via, and within, the acutely narrowed and repetitive photographic act.

The horizon line runs through the linear experience of this book and this series by threading together a range of experiences. The horizontal form is consciously used in these images to allow us a profound, and simultaneous, surveying and scanning of our contemporary environments by conflating and connecting different points in time to create a cumulative historical tableau that situates destroyed and disintegrating cities alongside landscapes in the process of regeneration. The horizon as a picture form is a brilliant visual metaphor for Leong's approach to photography because it embodies the precise line between us and the unseen. Just as we register the horizon as the perspectival limit upon the infinite curve of the globe, we become absorbed in the dazzling details of each scene, far beyond the limits of our real-time perception of a landscape. Even the architecture and the moisture mists that sometimes obscure our "view" constitute entities that are normally beyond our human vision.

I keep turning back through the sequence of *Horizons* and marveling at the myriad relationships it constructs. Despite that this book contains just under one hundred and fifty pictures, it is a ruthless edit because of the way the contingent sequential meanings evolve and renew throughout. Photography's inability to preserve the scale and size of its subject is played as the medium's unique strength in *Horizons*—creating connections and distinctions between places that are practically and profoundly separated by geography and economics. *Horizons* embodies an astounding fluidity that might seem to contradict the uniformity of its picture form. For me, the true artistry of Leong's project is his treading with rigor along a very fine line into a space where we can project our view into the unknowable and the infinite.

1. *Sze Tsung Leong, "A Picture You Already Know," in Words Without Pictures, ed. Charlotte Cotton and Alex Klein* (Los Angeles, 2009; New York, 2010).

In Conversation

JOSHUA CHUANG and SZE TSUNG LEONG

Yale University Art Gallery, March 12, 2013

SZE TSUNG LEONG: The Yale University Art Gallery was the first public institution to acquire a set of *Horizons* prints, which was important for this series because not only did it become a part of such a respected collection, but also the context of Yale's Betts House was unique, one that closely aligned with my intentions for the series. I've wanted to ask you about the background behind your selection of the works, and how they function in the context you created for them.

JOSHUA CHUANG: Over the past decade, one of Yale's priorities has been to be more global in its orientation, and the Betts House has been a major hub for this activity. The building is home to three international initiatives on campus, among them the Yale World Fellows Program, which was conceived as an intensive training ground for emerging leaders from other countries. Every year, a select group of people from a variety of sectors—including government, business, journalism, and the arts—are invited to spend an entire semester at Yale. Each of them has an office at Betts House, and many of their events and gatherings are held there. I was asked to develop a permanent display of artworks that would be installed throughout the building to provoke thought and stir discussion, and something about the pictures I had seen in your studio clicked.

What attracted me most to your *Horizons* work for that context was not only the range of sites depicted—Lisbon, Mexico City, New York, Hiroshima, Paris, Chongqing, and Essen among them—but also the unassuming way in which each picture subverts our assumptions of how a particular place should look. The photographs ring the common space of the top floor of the building, and they kind of wash over us if we're just sitting there reading or having a conversation. But as we get closer and begin to look at each one—without the aid of wall labels, which are far off to the side, as you had intended—we start to wonder where we are and why we've never seen that place in quite that way before.

Betts House, and the university as a whole, is committed to creating an environment of inquiry, of discourse across boundaries, of engaging openly with ideas and perspectives that might not be our own. The installation embodies the notion that there are many ways of seeing something, all of them worthy of consideration. The feedback I've received is that people truly appreciate that the pictures don't have an inherent bias or narrative agenda.

SL: The installation at Betts House is a compelling example of the unique conversation that works of art can have with the context they're displayed in, and also of the conversation that happens between the image and its viewer. That's why the raw encounter with an image, without the influence of reading a caption or text beforehand, is so interesting to me because it can evoke associations, memories, and questions that are much different than if we're told where these places are. I've shown *Horizons* in many countries, and in each country I've seen how viewers often close the distance when they look at images of places that are unfamiliar or faraway to them. They do this by finding the commonalities between places that seem unrelated. So, in New York, a viewer told me that she thought an image of Kaohsiung was New Jersey, while in Monterrey, Dubai was Chihuahua to another viewer, while in Shenzhen, a development outside of Minneapolis was construction in China.

One of my hopes is that these images will encourage viewers to question the boundaries and borders, which are often arbitrary, that we set for ourselves and the world. It's an experience I also wanted to create in this book.

JC: Without captions, we approach these views without preconceptions. Knowing what the sites are beforehand can short-circuit a valuable experience. When I look at one of

your prints, I can almost feel the weather. It's as if I'm right there, and for a few moments that sense of presentness becomes more important than knowing what I'm looking at.

SL: An important part of creating that sense of presentness is the physical nature of the prints. While photographs can exist in so many forms—in books, on screen—the most important form for me is the print itself. The print's unique qualities as an object can create a specific, and, hopefully, contemplative and focused viewing experience.

JC: I agree. On a superficial level your work can appear coolly objective at first, since the photographs are generally taken from a distance and printed so that the light is uniform. But that initial perception quickly dissolves when one looks at your prints. They convey a very human sensitivity to the subject—a result, I think, of your ongoing commitment to making each one by hand in the darkroom. This, in the age of digital printing, which has a tendency to make images look too perfect. And then there's the N-surface Kodak Endura paper you prefer. From my days of printing my own color work, I recall the warm personality of that paper, the way it could render nuances of tone and color, especially in the shadow areas of a picture. There's nothing else quite like it.

SL: A memorable and rewarding encounter with original prints for me was when, several years ago, you and I had the opportunity to leaf through some of Felice Beato's original mid-nineteenth-century prints at the Museum of Modern Art in New York. I was first drawn to his work because he was one of the first photographers to embark on photographing the larger world. But what was so revelatory about seeing his actual prints was their clarity and dimensionality, which gave their subjects a sense of materiality and presence. Part of this is due to the sharpness he achieved through his use of glass negatives. At the same time, his prints have a remarkable smoothness, a result of his use of wet collodion chemistry, which gave him a tremendous tonal range. Ultimately, seeing his prints brought up the relationship between the content of the photograph and the actual physical qualities of the print, about how the cognitive level of comprehending meaning overlaps and mixes with the perceptual level of seeing.

JC: Even though the tools and techniques that Beato used to create the illusion of continuity were crude by today's standards, the pictures we saw that day had a remarkable liquidity—especially the panoramas, which were made up of two, three, sometimes six prints pasted together.

It's worth noting that the seeming neutrality of Beato's work—especially that of China during the Second Opium War—masks a highly partisan view. He was a commercial photographer and his primary patrons for those pictures were British officers interested in a visual record of their empire's military might. But the documents that Beato made transcend propaganda. They possess a richness and specificity of detail that makes every part of those pictures fascinating to look at, even if we're not aware of the sociopolitical context they were made in. Those specifics are our entry points into those pictures. They allow us to form our own readings, which I think is why they are still so resonant. Obviously, there's a connection with your goals in *Horizons*.

SL: Yes, in my work, I'm interested in making images that are specific and palpable by compressing precise, articulated details into the relatively small space of the print—often to a degree that is greater than what we can normally see. Yet at the same time I want to convey how the ways we interpret and look at the world are so fluid and variable. It may seem like a paradox that visual clarity can coexist with ambiguity and variability in meaning, but it's part of what makes looking at images so interesting. Seeing Beato's images now, with the passing of more than a century, makes us aware of how fluid meaning is, how meaning changes depending on who sees the images and the historical context they're seen in.

A parallel way I've thought about this relationship between vision and fluidity is how fluidity is physically imbued in the making of images, both in painting and photography. One reason why I think Johannes Vermeer's work looks so photographic, so realistic, is his blending of tones by painting "into the couch," that is, into a wet layer of medium. This allows the paint to spread and mix slightly, creating soft edges such as the diffuse haloes around his highlights. At the same time, his paintings are extremely detailed and crisp. Having both softness and clarity at the same time is related to Beato's wet collodion

process and to my interest in the chromogenic printing process, where the color dyes are developed in wet chemistry, blending and mixing in ways that also give a smooth, continuous feeling to an image, while retaining a high degree of sharpness. Perhaps this rendering of colors and tones in a liquid medium is so dimensional because it approximates the way we actually perceive the world, when the image in our eyes passes from the lens, through the fluid mass of the vitreous humor, onto the light-sensitive retina. Ultimately, smoothness is important to me not just in a visual sense, but also in a conceptual sense, and gets back to how comprehending meaning mixes with seeing. Even though we often try to understand the world by creating dichotomies, the reality is that infinitely subtle gradations and overlaps exist, both in meaning and in appearance, in anything we look at.

JC: Your conceptual framework for this body of work brings to mind the 1975 *New Topographics* exhibition, which featured formally rigorous and unsentimental images of paradoxical landscapes. Though it threw a bucket of ice water on those accustomed to seeing the world through the romantic lens of Ansel Adams, it also served to reclaim the landscape as a subject of serious artistic and intellectual inquiry. I see your work as having benefited from this legacy, especially in the deft way you balance the inclusion of elements with historical or cultural significance with a spareness that allows viewers to inhabit the picture with their own perceptions and associations, and come to their own conclusions. Can you talk about this?

SL: I see landscape as the physical, formal manifestation of the many forces that drive our world. They can be the geological forces that shape the topographies of our environment, or the cultural and political forces that shape our territories and buildings. For example, the images in one sequence all have to do with religion in some way—the way it shapes territory in the West Bank, the way it is built into form in the Vatican, or the way it transforms sheep from living animals into symbols.

In this series I've been preoccupied not only with the single image, but with what happens when several images are juxtaposed. Often these relationships can be surprising and unexpected. For example, I intuitively placed an image of the Chicago skyline next to an image of the Masai Mara, and then realized that this pair suggested the historical idea of the West in the United States, how at one point it marked the frontier with a vast, bison-filled wilderness beyond. Next to this pair is an image of a development in California, the westernmost point of continental expansion. These themes of the frontier, of the spread of human territories and its relationship to the so-called wild, came up unexpectedly for me, as I hope other unexpected themes and readings also will for whomever looks at these images.

JC: In that particular arrangement, we have a view that has probably remained unchanged for centuries, next to a view of a decidedly contemporary landscape, next to another recently developed view. I think it's vital that you've sequenced your pictures without a beginning, middle, or end, because the meaning of the project as a whole would otherwise be too neatly understood.

As still as they appear, your images are landscapes in the state of constant transition. They have a timeless quality that is emphasized by the way you've arranged them and by your choice of vantage point. They have many possible points of connection and many avenues for productive engagement, whether on a geographical, environmental, historical, or visual level. Behind the apparent simplicity of your concept is a wealth of complex detail. Can I ask what you look for when you decide to put one image next to another?

SL: It's many different things, and I try to create a wide range of relationships between images. On a basic level, a visual resonance can exist between images, and it might be between forms, for instance, between the sacred pyramidal rocks at Meoto Iwa and the salt cones in Bolivia, next to the pitched roofs of speculative houses in Victorville, next to the bent pyramid at Dahshur. These images show how a simple form can inhabit realms of belief, geology, economics, and society in such different ways. On another level, images of different kinds of walls, such as the separation barrier in the West Bank next to the Three Gorges Dam in China, might show how both are efforts at containing flows, whether of people or nature. Or, juxtaposing images of cities such as Jerusalem, Mexico City, Rome, and Astana might make time and history visible by showing how power is

expressed through the centers of the civilizations of different eras. These relationships

JC: Right. Whenever you put two images next to each another, you put them into a conversation. The challenge, then, is to orchestrate a conversation that is as interesting and as meaningful as possible, rather than to just follow a predisposed line of thought. Editing, of course, is one of the most difficult and vital aspects of a photographer's work. If you're doing it right, you're constantly placing your own assumptions on the altar, hoping they survive. If they don't, it's back to the drawing board. Can you talk about the editing and sequencing of the images for your book?

SL: I've worked on this series for more than a decade, and from the countless photographs I've taken over this period, I chose about a hundred and eighty images to work with for the book, out of which a hundred and forty-four made the final edit. Sequencing the book was like putting together a very complex puzzle, where changing one piece would change the whole, since I wanted the relationships to be continuous and have a momentum. So, some of the images I'm fond of didn't make it into the book only because they didn't work in this particular context, but in other contexts they'd be successful. Editing and leaving out are two parts of the process I go through with every sequence and installation. It goes back to that aspect of the work that is always changing, depending on the context.

JC: Sometimes when I think I've "gotten" your work, I'll find something in one of the images, or even in a juxtaposition of images, that will undercut whatever it is that I had previously understood. It's one of the reasons I find it so intriguing to return to your work again and again.

Since the work trades in contradictions that are inherent to the history of civilization, you could probably keep the series going for years without exhausting all of the possibilities. This said, how have you chosen your sites thus far? Is it a strategic or intuitive process?

SL: I'd say it's a combination of many different factors, including the two you just mentioned.

In choosing sites I try to find as much difference as possible. So, I go from the extremes of temperature, for example, from a tropical sea to icebergs, or the extremes of culture, say, from Havana to Banaras to New York, or the extremes of topography, from the vertical slopes of the Andes to the flat emptiness of the Dead Sea. It's an effort to picture the world, to picture enough of a slice of the world to give this idea of vastness, of really stepping back, stretching out the range of our field of vision along an extended horizontal line, and creating a virtually limitless angle of view.

JC: Those extremes are traversed in your work, I think, by your consistent approach to such varied geographies—specifically the way you've composed your pictures so that the identifiable content of a given place sits in the lower third of each image. It has the effect of equalizing them visually, which makes them more pliable and useful as building blocks.

SL: Connecting images of places with a common straight line is similar to the way that the surface of the globe equalizes disparate places on the same plane. While this plane unifies, it also makes opposites—such as proximity and distance, foreign and familiar, difference and homogeneity—simultaneous. In a way, Horizons is a representation of that global surface, but unfurled, with its connections, disjunctions, and contradictions all aligned.

JC: I'd like to talk about another aspect of your work that has to do with form, which is your tendency toward Minimalism. Does your work have a relationship with Minimalism as it concerns the history of art?

SL: In addition to the different conversations we've talked about—between art and its context, art and its viewer, or two or more images—is the conversation between the artist and history. Today, the range of this conversation is more varied than it has ever been. Along with the histories we've discussed—seventeenth-century Dutch painting, nineteenth-century photography, New Topographics—Minimalism has become an important part of my dialogue with the history of art. Many of the concerns associated with this movement—serial repetition, pure geometries, engaging the space around the object,

creating a direct relationship between the viewer and the object—are the same concerns I've been preoccupied with for *Horizons*. Perhaps what I've learned the most from Minimalism is how reduction both in form and in the rules we use to make form can focus and sharpen the way we see, to reveal so much complexity and difference. The challenge of this approach is to reduce but not impoverish, to create a feeling of absence and nothingness that is present and full at the same time.

JC: Another aspect that makes the series so visually absorbing is its surprising range of atmospheric densities and your catholic handling of color. Your palette is so varied, open, natural, and restrained that it's hard to identify easily, unlike, say, that of circa nineteen-seventies Stephen Shore or William Eggleston. When we look back now at color photographs from the seventies and eighties, something about their color makes them look like they're from that time. But your palette has an elusive, chameleon-like quality that helps to focus the viewer's attention on aspects other than when the picture was made or by whom. I think this contributes to the timeless quality I referred to earlier.

SL: Color is fascinating to me because the way we perceive it is so mutable and elusive. A good example is the skies in my prints. While they may look uniformly gray and monochromatic, they actually contain a subtle and shifting range of color that changes as you look. What initially appears empty and colorless will reveal hues that shift slightly, from yellowish to reddish, from purplish to bluish. Our eyes can perceive an almost infinite range of gradations of color, even within a limited spectrum. Color not only gives intelligibility to the world—from distinguishing forms to evoking emotion to imbuing specific meanings to different cultures—it's also an analog for the wide range of shades and nuances in how we understand what's around us.

JC: Garry Winogrand once said that he photographed to find out what something looked like photographed, which implies that a photograph is somehow different than the reality it purports to record. Is creating an accurate or truthful record of your experience of the world something you're after?

SL: The truth, like color, can range from definite to elusive. When looking at a color, you can start by saying "this is green," but then the more you look at it, you start asking if it's a bluish green, or a yellowish green, and so on. In images, how you perceive the truth depends on how you read the image—it can start off appearing one way, but the more you look at it, the more a wide spectrum of possibilities opens up, and different truths, perhaps independent from what the image is depicting, start to coexist.

In my work I try to extend the gamut of what we can see, whether it's of information and detail, of shade and nuance, of history and time, or of field of vision. By expanding the range of what and how we normally see, I hope that my images won't channel the viewer into any single or obvious truth, but will be open and inhabitable, ambiguous in ways that illuminate rather than obscure, and give a sense of freedom and possibility, like being in a wide unencumbered space. For me, this type of open ambiguity is an essential part of image making and contributes to the richness of seeing.

JC: Ambiguity is a useful motif in your work. When it appears, I find it to be principled and structured rather than arbitrary. So much contemporary art revels in ambiguity, but it's only meaningful if the artist finds a way of dealing with it, finds a form for it, if you will. Otherwise both artist and viewer will be lost.

At the heart of *Horizons* is an intriguing paradox between its overwhelming abundance of visual information and how little of that information can truly be comprehended all at once. We might begin by trying to identify small, concrete details to relate to—a style or density of architecture, for instance, or a type of flora. These details, however, can remain inscrutable even as they are seductive.

The fact that the views you've made are, to many of us, more foreign than familiar, more sky than land, invites us to bring our own ideas and perspectives to your work, even if our notions need to be opened up, changed, or sharpened. What happens when we look again and again through the sequence of pictures is a kind of feedback loop, a gradual and accumulative process of refinement. Each time we re-engage with your work, we take away a bit more knowledge to augment our comprehension of the whole. It's a gratifying process, and a guide, I think, for living in the world.

Jerusalem Athens Alexandria Unreal

PICO IYER

I AM WALKING through winding streets in the Old City of Damascus, slipping into the Umayyad mosque as the first call to prayer rises up, just before dawn, and losing myself in the stillness and surrender of the early petitioners on the carpets around me. Alleyway leads to narrow lane to alleyway so narrow that houses on opposing sides touch. I'm in a Venice without tourists in Damascus, and when I go into the Shia mosques nearby, built here by Iran, people are sobbing and rubbing their hands around the grille behind which the great-granddaughter of the Prophet is buried.

That same day I'm in London, picking up e-mails in Covent Garden, and then what feels like the same day, I'm in the blithe, unhistoried sunshine of Santa Barbara, California. In two days I fly back to my home—where I've lived for twenty-three years on a tourist visa—in rural Japan, a twenty-first century artifact built on the Californian model, though infused, insofar as I can tell, with the ancient values of the great Buddha and the central deer park down the street that recall the capital of Japan in the year 710.

This was how my millennium began, and it is how many of my days since have been, Jerusalem to California to Japan in successive days, California to Beijing to Delhi and then Mauritius. Often I lose track of where I am. Only this week I realized it was a month later than I had thought. My self goes through imperceptible shifts, too, as day becomes day becomes day again, and I'm looking for lunch at what the clock calls two in the morning, and turning in for the night in the early afternoon.

Yet deeper than all these curious shifts (jet lag, recall, hadn't been described as such until 1956) is the eerie sense—more intuited than analyzed but half-felt if barely understood—of moving, around the backwards-running clock, from Rio to Los Angeles to Hawaii, and looking for what changes and what remains. The speed at which we move around the globe today, even if we're sitting at home and only switching screens, makes each of us a chronicler of time-sickness, an observer of constantly shifting horizons, wondering how we can possibly put the vast open spaces of Dubai with the great ice fields of the far north, or why (whether, indeed) we are seeing pyramids as we travel from Dahshur to the salt cones of Bolivia to triangular roofs in the California of the future.

I think of one of those great East Asian handscrolls in which the seasons are ceremonially unraveled in a scene that starts in spring and concludes somewhere in winter (though the single continuous canvas suggests that all this

back to classical East Asian art again—is the negative space around his silhouettes and look-alike cities, the larger canvas that puts everything in its place, as it were. The eye moves not just toward the horizon, which this work singles out, but to the empty sky that sits above everything and renders it a haunting whole.

Up close, though, all we are aware of is how abrupt the shifts are from Germany to Jordan. Much of the fascination of this work, its energy, lies not just in the individual canvases but in the current between them, the charged space that links them, the very fact of passage from one almost arbitrary-seeming location to the next. Leong takes the fractures and disruptions of our postmodern floating world and weaves them into a seamless flow in which distances dissolve, history fades away, and we are asked what to make of the often disembodied sense of unearthliness that results.

What he seems to do for me, then, is just what I was trying (though mostly failing) to do when the millennium began: to make peace between the centuries and continents, to find the echoes, and the groundings, that will allow us to stitch together otherwise random experiences and scattered moments. When I think about the aesthetic, the larger vision behind this work, I am moved to reflect upon his name: what seems to me to be a set of syllables from the other side of the world. But when I take in the details in each landscape, I see his life: in motion, outside any single nationality or ancestry, taking in pieces of Mexico and England and Malaysia and Canton, putting together the Mexico City and London and Houston,

human pageantry is part of the same story, deep down). I see the same Manchester United and Real Madrid game up on screens as I get on a plane in Singapore and, through tape delay, as I get off the plane in San Francisco. I hear the same Muzak, the same version of "One," the same "Like, you know" as I fly from a mall in Beirut back to Burbank. But in the classic handscrolls of the East there is a steadying sense of ritual and deliberateness, humans observing the seasons as a way of placing themselves inside a larger frame. In today's world, each one of us, propelled at the speed of light out of time and space, has to try to construct his or her own sense of continuity and make the connections, human and cultural, that link one confounding vista to another. As T. S. Eliot wrote almost a century ago:

What is the city over the mountains
Cracks and reforms and burst in the violet air
Falling towers
Jerusalem Athens Alexandria
Vienna London
Unreal

~

When first I looked at Sze Tsung Leong's elegant and deeply contemplative work with horizons, two things struck me: the way his subjects blur into one another, as if all part of the same story, and the way they don't fit together at all. From afar, his real theme—here, I think

where he has lived, in his current homes in New York and Los Angeles.

He is one of us, in short, the new tribe—I think of it as a Fourth World—that is living outside the old categories and definitions of home, that is having to construct a new sense of belonging and even of self in the blur of many places equally home to us and equally foreign. It is as if all the places on an airport's departure board are part of our daily lives now, in quick succession. We are flying through Cairo, Allahabad, Kazakhstan as fast as those great generic boards flip through the very names. We see the similarities, in human emotions, in a shared pop culture, in light and sky and proportion. We feel the differences, in surfaces, customs, and assumptions. Home is to be found, if it's to be found at all, in passageways, or in the act of transition, of observation itself.

The greatest blessing of the new century, for the fortunate among us, is mobility—the chance to shed a sense of Other, the opportunity to sample, learn from, and give back to cultures that in my grandparents' day were unimaginable, as far away as Jupiter. But the greatest challenge of the twenty-first century, its inescapable bass note, is how to hold our own amid disjunctions, how to find a still point in the turning world. And how, as in this classic and highly contemporary work, to find solace and even meaning in what can seem as disparate and displacing as an endless sequence of dissolving images on a screen.

It's worthwhile, I think, to recall that Leong's previous work was the perfect companion piece to this one, a disturbing yin to the meditative yang of *Horizons*. In

History Images he gave us visions, equally unflustered, of decay and transformation and palimpsest. If his previous book was about the way modern China, for one, is erasing all guidelines and traditions, blending tenses into a kind of North Korean perfection, this serene and detached work with horizons is in part about everything that stands around that chaos, the stillness and emptiness and centeredness that puts it into perspective. Leong is the rare global traveler who hasn't lost his balance, and what he is offering us in his work is a calm, disengaged, synoptic view of the planet as it looks to one clear-eyed, unaffiliated wanderer, who has a part of himself in many places, but the whole of himself in none. Or only in the mind.

In Japan, every autumn, I notice how the light sharpens and the leaves turn gold and red and people hurry out to observe the coming of darkness under usually cloudless and radiant blue skies. But that change is itself a constant, which puts my neighbors in the same frame as their ancestors, from the eighth century, or from the culture on which theirs was modeled, T'ang Dynasty China. They are reflecting on passages even in the twenty-first century and so too, I realize now, are Leong and more and more of the rest of us, grounded in change, and sustaining ancient structures and proportions even in the movement that is our home. I take off again next week—Ireland, England, California, Japan, Hangzhou before the month is out—and as I step onto the plane, past the departure board, readjusting my watch, I think of the even line he's given me, the secret connection that links east to west to desert to city, and I close my eyes and breathe.

ACKNOWLEDGMENTS

ONE OF THE MOST profound rewards of doing work meant to engage others is my own engagement with the many individuals throughout the world who have supported me with kindness and generosity in realizing this work. In the more than twelve years since I began this series, this list has grown long, and of the many, I would like to mention a few in particular.

I am deeply grateful to Yossi Milo, whose belief in, enthusiasm for, and dedication to my work has been such an essential part of my ongoing life as an artist. I am indebted to Alissa Schoenfeld and the staff at Yossi Milo Gallery, whose tremendous hard work on my behalf leaves me humbled.

Markus Hartmann has steered this book through the choppy waters of art book publishing—to him I extend my utmost thanks. The skilled and focused staff at Hatje Cantz Verlag—in particular Nadine Schmidt, Tas Skorupa, Caroline Schilling, and Martina Reitz—have made the realization of this book such a wonderful experience, as has the expertise of Jan Scheffler at prints professional.

My dialogue with the thinkers who have contributed to these pages has enriched both me and this book, and I'm fortunate to have their viewpoints coincide here with the views I've made. Early on, Joshua Chuang cast his discerning eye on my work and gave it one of the most interesting environments in which it could be shown. Engaging with him and his perceptive enthusiasm for photography have been enormously important to me. I was honored when Charlotte Cotton asked me to write an essay for one of her books, and I continue to value our dialogue both on the page and off. I am profoundly grateful to Duncan Forbes for creating two spaces for *Horizons*, one within the National Galleries of Scotland, and the other within the insightful, passionate intelligence of his essay. Not only am I tremendously privileged to have my work reflected on through Pico Iyer's boundless and compassionate worldview, but I've also found in him an affinity and kinship in so many fundamental and meaningful ways that includes, no less, our shared Anglo-Asian-Californian backgrounds.

The artistry of photographic printing, chromogenic and otherwise, is no safer than in the capable hands of Gerard Franciosa and Andrew Carlson at My Own Color Lab in New York. Working with them and with the lab's present and past staff—particularly Scott Eiden and Steve Eiden—has been an immense pleasure. My thanks also to August Pross, Justin King, and the staff at LTI-Lightside for their patient and discriminating work, and to Stacy Renee Morrison for her dedicated attention to detail.

I thank the scholars, curators, directors, gallerists, and editors who have supported me, for finding in my work something worthwhile, for sharing their observations, insights, and challenges, and for bringing my work to a wider public: Svetlana Alpers, Shoshana and Wayne Blank, Bertha Cantú, Gloria Chalmers, James Crump, Malcolm Daniel, Douglas Eklund, Dan Esty, Dana Faconti, Mia Fineman, Emiliano Gandolfi, Ellen Kelly Ginsberg, Dana Golan-Miller, Hou Hanru, Suzanne Landau, Dan Leers, Dalia Levin, Joanna Milter, Yasufumi Nakamori, Ou Ning, Jennifer Pastore, Sandra Phillips, Brian Sholis, Debra Singer, Joel Smith, Vesela Sretenovic, and Anne Tucker.

The support and friendship of John Hass and Mary Frances Budig is a sustaining gift to me—to them I will always be grateful. Hanya Yanagihara has encouraged and helped me in such significant ways—to her my unwavering gratitude and affection. I would also like to thank the many collectors of my work, including Philippe Berthe rat, Paul Brennan and Paulo Pacheco, Allison and Steve Brown, Catherine Nelson Brown, Eva Ching and Jeffrey Small, Bevin and Bill Cline, Ilan Cohen, Shawn Warren Crowley, Gerald Frug, Tracy Higgins and Jim Leitner, Even Hurwitz, Jay Luchs, Christine and Arnaud Maquet, Elizabeth and Michael Marcus, Ronay and Richard Menschel, Marlene Meyerson, Megan Mullally, Sandy and Les Nanberg, Susan Sarandon, Ben Stiller, Gary Sokol, Gloria and Paul Sternberg, Christine Symchych, and Allen Thomas. My warm appreciation in particular for the continuing generosity of Sue and Bob Grey, Alison MacLennan, Kenneth Schweber, Doron and Adi Sebbag, and, not the least, Evan Smoak.

My gratitude to those who have lent their support, knowledge, and help around the globe: Mohammad Ali Abou Samra, Saladin Abu Elliel, Jeebesh Bagchi, Narayan Basnet, Banu Cennetoglu, Patricio Crooker, George Gituku, David Goldes, Daniel Guevara, Han Yan, Nera Kelava, Jung Whan Kim, Ashish Mahajan, Monica Narula, David Nganga, Sebastian Ormachea, Luca Paschini, Navneet Raman, David Sims, Raghoo Sinha, Sameh Wahba, Lara Warmington, Albert Waweru, Adam Wiseman, Noel Worden, and Alfredo Zeballos. My heartfelt thanks especially to Ferran Mateo, *mi hermano*, for opening so many doors in so many countries for me.

Most of all, I owe the world, beyond words, to Judy Chung, to whom I dedicate this book, not only for shaping the words in this volume with sensitivity and beauty, but ultimately for experiencing the world with me with inquisitiveness and wonder, for opening up new worlds for me with care and thoughtfulness, and for helping me see ever farther and understand ever further.

BIOGRAPHIES

SZE TSUNG LEONG is a Mexican-born, American and British artist, currently based in New York and Los Angeles. His work has been exhibited internationally, and is included in the permanent collections of the Metropolitan Museum of Art in New York, the National Galleries of Scotland, and the Yale University Art Gallery, among others. Mr. Leong is the recipient of a Guggenheim Fellowship, and his previous series, *History Images*, was published as a monograph in 2006.

JOSHUA CHUANG is the Chief Curator of the Center for Creative Photography in Tucson, Arizona. In his prior position as Associate Curator of Photography and Digital Media at the Yale University Art Gallery, he organized the touring retrospective *Robert Adams: The Place We Live*, along with a related series of publications. He has also contributed to monographs on the work of Lee Friedlander, Judith Joy Ross, and Mark Ruwedel, and has written and lectured widely on postwar American and contemporary photography.

CHARLOTTE COTTON is a writer and curator. She has held positions that have included Curator of Photographs at the Victoria and Albert Museum and Head of the Wallis Annenberg Department of Photography at the Los Angeles County Museum of Art. She is the author of *The Photograph as Contemporary Art* and founder of *Words Without Pictures* and *eitherand.org*.

DUNCAN FORBES is Director of the Fotomuseum Winterthur, Switzerland. He was previously Curator of Photography at the National Galleries of Scotland, Edinburgh, and a lecturer at the University of Aberdeen. His most recent publications are *Edith Tudor-Hart: In the Shadow of Tyranny* and an essay for Eva Vermandel's book *Splinter*. He is currently working on an exhibition about the relationship between photography and the manifesto.

PICO IYER is the author of two novels and eight works of non-fiction, including *Video Night in Kathmandu*, *The Global Soul*, and *The Open Road*. An essayist for *Time Magazine* since 1986, he writes on many topics for *The New York Times*, *The New York Review of Books*, and magazines around the world. Born to Indian parents in Oxford, England, and raised between Britain and California, he has long been based in rural Japan when not traveling to North Korea, Ethiopia, Easter Island, and most places in between.

COLOPHON

Text editing: Judy Chung
Book design and image sequencing: Sze Tsung Leong
Production: Nadine Schmidt, Hatje Cantz
Typeface: Sabon
Reproductions: Jan Scheffler, prints professional, Berlin; and LTI-Lightside, New York
Paper: Profisilk, 170 g/m²; Plano Plus, 140 g/m²
Printing: Offsetdruckerei Karl Grammlich GmbH, Pliezhausen
Binding: Buchbinderei Ammering

© 2014 Hatje Cantz Verlag, Ostfildern, and authors
© 2014 for the reproduced works by Sze Tsung Leong: the artist

Published by
Hatje Cantz Verlag
Zeppelinstrasse 32
73760 Ostfildern
Germany
Tel. +49 711 4405-200
Fax +49 711 4405-220
www.hatjecantz.com
A Ganske Publishing Group company

Hatje Cantz books are available internationally at selected bookstores. For more information about our distribution partners, please visit our website at www.hatjecantz.com.

A Collector's Edition, consisting of two signed and numbered c-prints by Sze Tsung Leong in a folder with the book, is available. The photographs (*Jebel Al-Ashrafiyyeh, Amman, 2007*, and *Parque El Ejido, Quito, 2010*), each measuring 24.9 by 45.7 centimeters, on a sheet measuring 40.6 by 50.8 centimeters, are a limited edition of 20 + 5 a.p.

ISBN 978-3-7757-3789-0

Printed in Germany